SPACE PROJECT

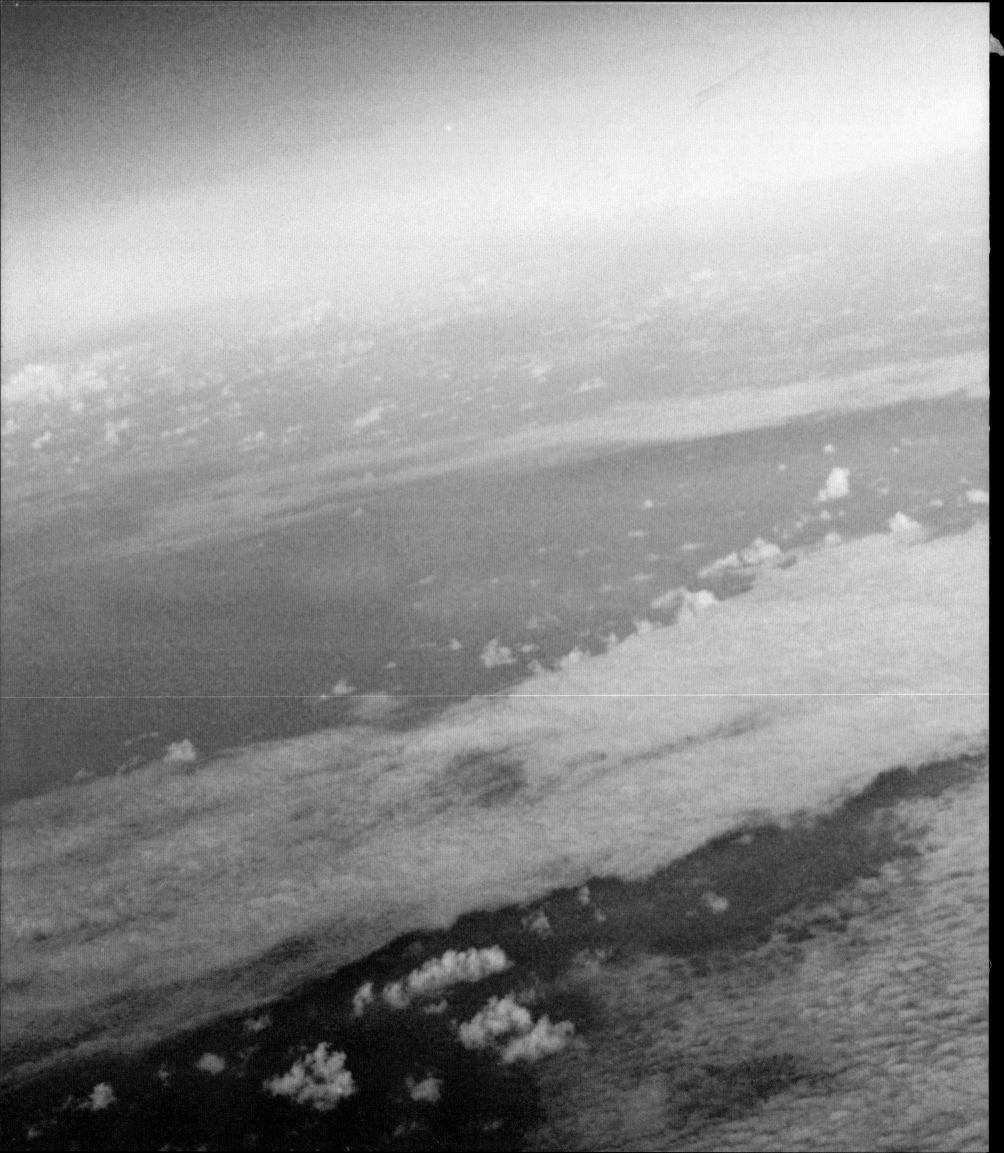

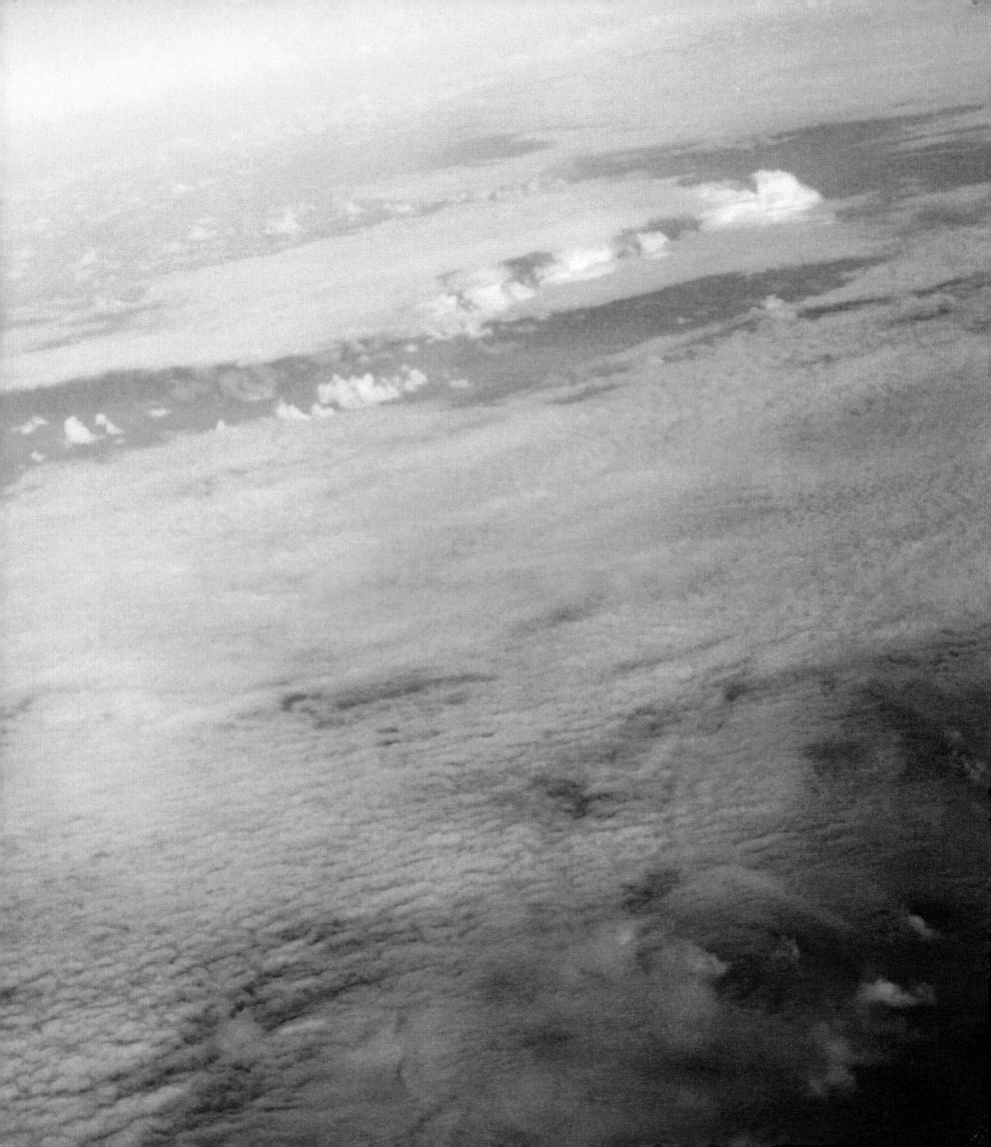

LYNN DAVIS

SPACE PROJECT

INTRODUCTION BY ALAN WEISMAN

THE MONACELLI PRESS

PUBLISHED IN THE UNITED STATES
BY THE MONACELLI PRESS
A DIVISION OF RANDOM HOUSE, INC.,
NEW YORK

THE MONACELLI PRESS AND COLOPHON
ARE TRADEMARKS OF RANDOM HOUSE, INC.

LIBRARY OF CONGRESS CONTROL NUMBER: 2009931817
ISBN: 978 1 58093 251 6

PRINTED IN CHINA

10 9 8 7 6 5 4 3 2 1
FIRST EDITION

DESIGN BY HELICOPTER, L.L.C,
WWW.HELLOCHOPPER.COM

WWW.MONACELLIPRESS.COM

PHOTOGRAPHER'S NOTE

For the last twenty-five years, I've been wandering the globe, photographing, among other subjects, sacred landscapes and ancient sites, geysers and icebergs, pyramids and temples, as well as modern and post-modern architecture. Often in the middle of a journey I've paused to glance up into the heavens, as if such glimpses into the endless void would add resonance to my worldly subjects below. Increasingly I wondered about the technology involved in the explorations of outer space and how and where such secret structures and launches were constructed and then activated.

It was only years later that such mysteries suddenly opened up for me when one evening I met a photography collector at the Edwyn Houk Gallery in New York City. Alden Richards had not only worked in the space industry for over twenty years but even more importantly he knew how to secure permission for entry into those remote sites where "blast offs" into the unknown took place. Immediately we decided to work together. The process was never easy and yet Alden's persistence never wavered. Without his enthusiasm and energy, our space project would never have taken place. I will forever be indebted to him for his tireless work, which made such a project not only possible but enjoyable.

As I proceeded photographing the space project, each site presented a unique set of circumstances. I was always pressed for time as well being inhibited by a ferocious set of restrictions involving each entry to a specific site. Not only did one have to secure a list of bureaucratic permissions but each particular site came with specific entrance requirements, often involving a very small spatial window to photograph. Regardless of the quality of light or time of day I rarely was able to focus on anything but a very specific image. The time assigned seemed often totally arbitrary, some of the sites being active while others were totally abandoned. Often I found myself standing in front of an amazing structure when I would be informed that the object that I was looking at didn't exist, which was a way of saying, "Do not under any circumstances photograph this forbidden site." Despite these obstacles I was able to see as well as photograph an amazing range of launch structures rarely visited by the uninitiated.

Space Mirror Memorial, Kennedy Space Center, Florida
Photographed 2003

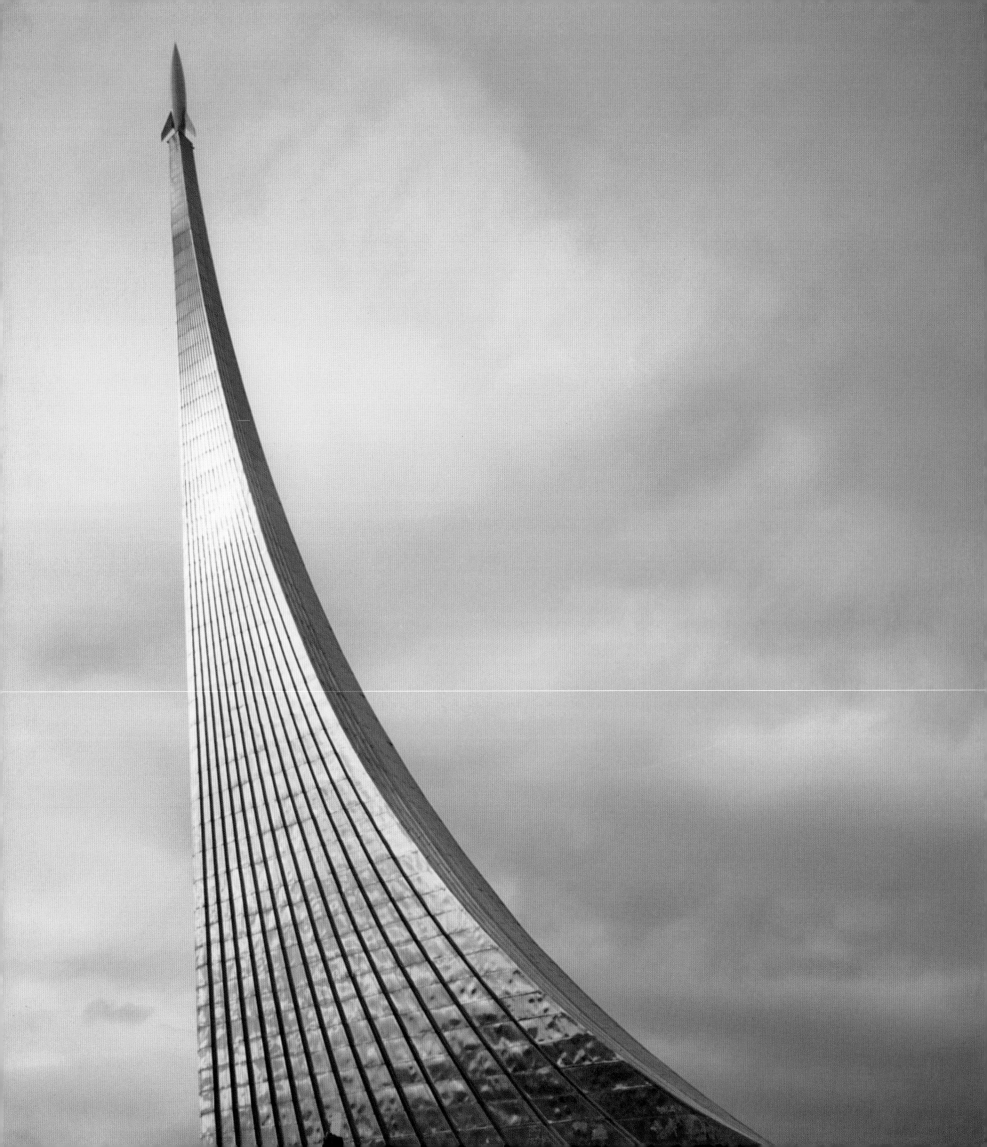

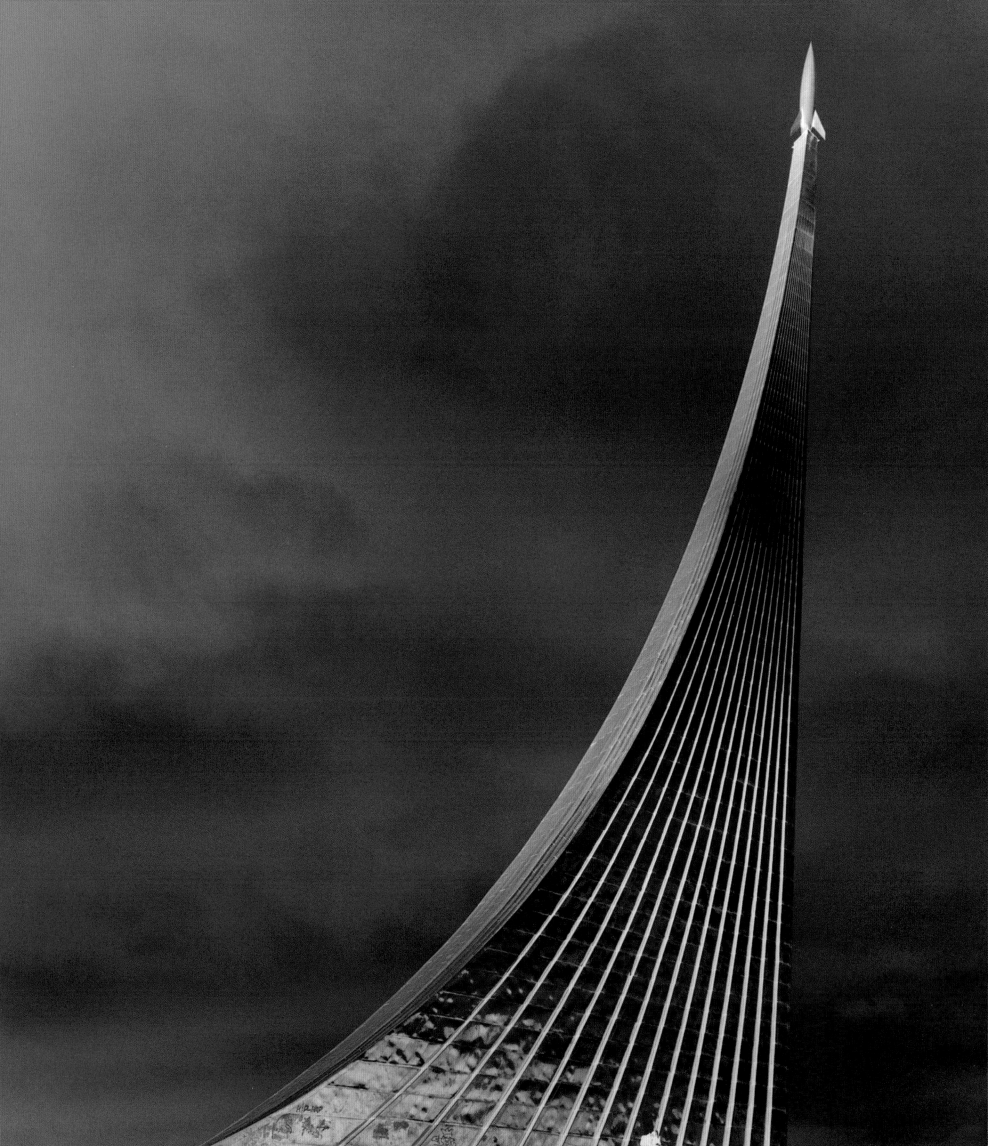

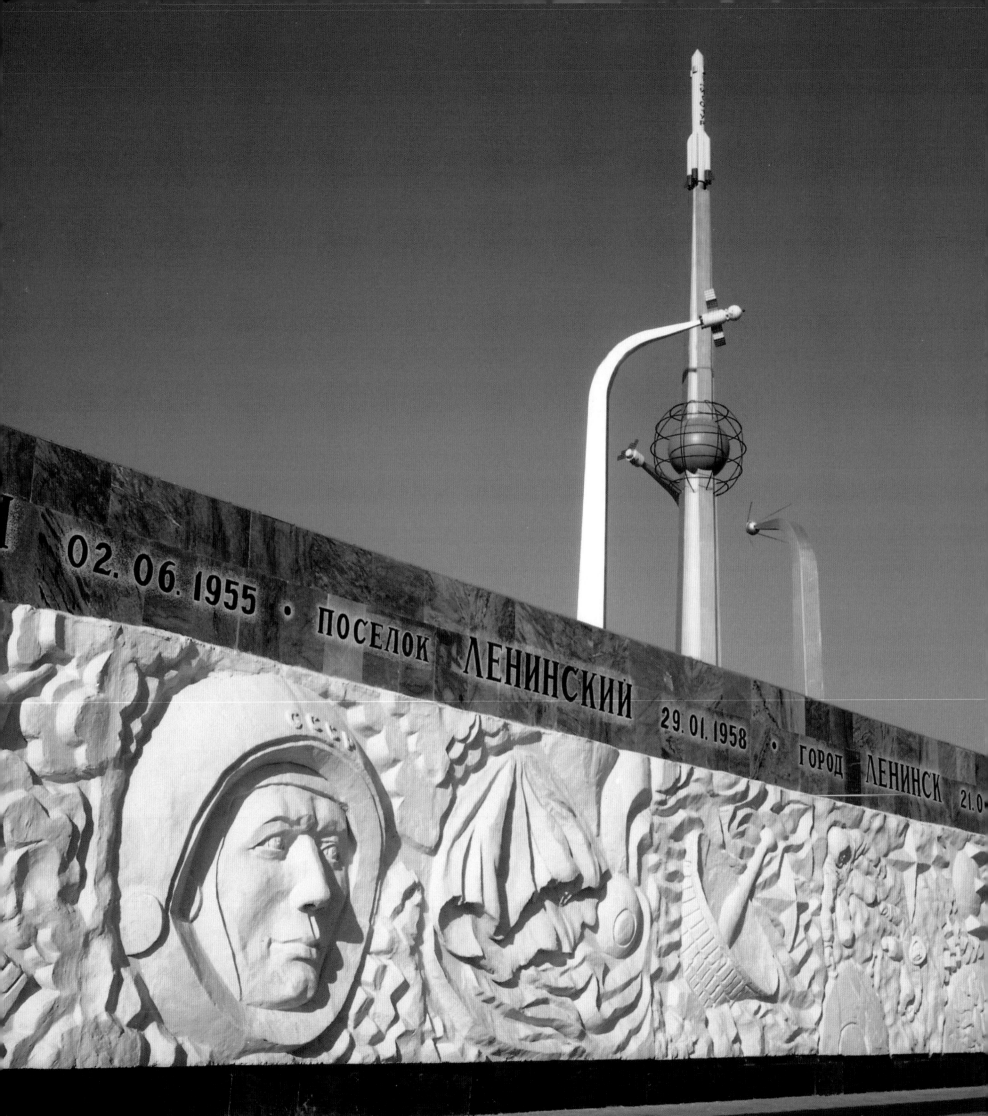

INTRODUCTION

ALAN WEISMAN

As a child, I would often fall asleep on winter nights with my forehead pressed against a cold window, mesmerized by the aurora borealis shimmering like a visitation over frozen Minneapolis. By coincidence, unknown to me, in another part of the same city that undulating curtain of unearthly iridescence—neither red nor green but somehow both—also hovered over the girl who would become photographer Lynn Davis.

Years later, we would meet in New York and compare northern memories, such as the original Minneapolis Public Library, a fine brownstone castle long ago razed for more parking lots. A small museum on its top floor contained a grisly Egyptian mummy and the heartbreaking, stuffed remains of an extinct passenger pigeon—but also an enchanting planetarium. Within its velvety black dome was projected a thrilling cosmos of neighboring worlds, mythic constellations, and distant nebulae. It was an oddly comforting place. Pharaohs might die and entire civilizations rot; the most abundant bird species on the planet could be

Monument to Yuri Gargarin, Baikonur City
Photographed 2003

Monument to the Conquerors of Space
of the VDNKh (1964), Exhibition Center, Moscow
Photographed 2003

annihilated in mere decades—but those planets, comets, stars, and galaxies were so pristine, safely beyond our mortal grasp.

Still, I yearned to touch them.

My early dream to become an astronomer crashed headlong into a barrier called higher mathematics. Today, however, I still treasure the chance to spend time with someone privileged to study space for a living—such as the lunch I had recently with Sydney Barnes, a brilliant young Calcutta-born astrophysicist from the Lowell Observatory in Flagstaff, Arizona. His specialty, which involves chemistry seething deep beneath the surface of stars, might strike some as scientific arcana irrelevant to life on Earth—except for the small detail that our Sun is a star very similar to the ones Barnes studies, and its behavior utterly rules our own.

In fact, our entire existence depends on it. And our continued existence on Earth increasingly may depend on things we can only learn from outer space—which sometimes means not just gazing at it from down here, but actually going up there.

For example, as Barnes explained to me over brioche and Greek salad, "Only from the vantage of outer space can we see if a mountain has grown by a millimeter. Or if the sea floor has risen that much."

And this matters…?

"When these phenomena are related to a warming globe. Only from the perspective of space can we measure changes on Earth with such precision."

His reply reaffirmed my gut response whenever I find myself defending the vast sums my species spends on space programs. At varying stages of maturity (or alarming decline) such programs are currently found in the United States, Western Europe, Russia, China, Japan, India, and most recently Iran. And in each of those places, well-intentioned people rail against expenditures on space when there are so many pressing needs here on Earth.

I am especially perplexed when I hear this from environmentalists in my own country. Since the entire American space budget amounts to barely one-seventieth of what the United States has annually bestowed on defense, I have a suggestion of where to start re-allocating tax dollars to save ecosystems. But a more fundamental reason to cherish the space program is that the modern environmental movement was born of it.

This isn't to detract from the role of pioneering naturalists and scientists such as John Muir, John James Audubon, Aldo Leopold, and Rachel Carson, whose eloquent voices and images were among the first to warn us of what we might irrevocably lose on the only planet we have. Unfortunately, they failed to reach or convince a critical mass of us. To most people, environmentalism wasn't even a recognizable concept until after a day in December 1968,

Our continued existence on Earth increasingly may depend on things we can only learn from outer space—which sometimes means not just gazing at it from down here, but actually going up there.

when humans first got far enough away from Earth to turn around and take its picture.

The photograph snapped by Apollo 8 astronaut Bill Anders of our home rising over the moon's horizon—so incredibly, sweetly alive and vibrant compared to anything else in any direction for millions of miles (or, for all we know, compared to anything, period)—may be the most influential image ever made. The following year, the United Nations declared the first Earth Day. By 1970, Earth Day had become a worldwide, mass movement. Environmental studies programs blossomed in colleges and universities, and science units in elementary schools metamorphosed into timely, exciting environmental education.

By 1972, however, two events—one on Earth, one in space—would inadvertently cloud our new ecological global vision. The first actually seemed to seal the case for the environment and inspire even more recruits. It was the publication of a report commissioned by an international think tank, the Club of Rome, which predicted that swelling world population and massive harvesting of resources to feed, fuel, and otherwise supply it were on a catastrophic collision course. *Limits to Growth* sold millions of copies worldwide, but its wakeup call was soon drowned by the roar of engines fired by the backlash it triggered. If the world was running out of resources, the harvesters figured, better grab them while they're still there to get. The ensuing splurge, abetted by reflexive mass denial that the good life might actually be subject to limitations, resulted in a

gloriously stocked global marketplace—the bills for which, unfortunately, appear now to be coming due.

The second, Apollo 17, also initially seemed a huge success. For the sixth time, humans landed on the moon. It was the first mission to include a scientist, geologist Harrison Schmitt. Besides sampling both the youngest and oldest lunar rocks ever encountered, Apollo 17 produced more remarkable photography, including dazzling panoramic and detail shots of the moon's surface. Most astonishing, however, was an exposure that Schmitt made en route with a 2¼-inch Hasselblad of the round face of planet Earth in full sunlight. Clearly depicting the Arabian Peninsula, Africa, Madagascar, and Antarctica amid diaphanous swirling clouds, Schmitt's photograph has surpassed Anders's *Earthrise* to become perhaps the most iconic image in human history. It was the first to show us as completely as one picture possibly could—but it was also the last of its kind. Since then, we've never been in a position to see our world that fully.

Until Apollo 17, it seemed like spacecraft with us aboard were destined to keep reaching for planets and stars. But then we paused and lost momentum. Save for redundant, low-orbit shuttle missions that never much aroused our imaginations—except for nightmares, when two horribly failed—and an uninspiring, tinny space station that has never evoked the grand flying-saucer-docking-station vision of our fantasies, humans have been grounded ever since.

Not that, Lynn Davis might say, there's anything wrong with focusing on the rich mysteries of home. For decades, the Earth and some of the most unforgettable marks we've made on it have been her subjects. Traveling lightly, armed with minimal equipment—mainly a venerable 2¼-inch twin-lens Rolleiflex—she has been on an extended pilgrimage through legendary landscapes to portray some of civilization's most revered shrines and antiquities. Working alone, in self-imposed silence, she has managed to refresh and deepen the meaning of even the most clichéd scenery, at places such as Machu Picchu or the pyramids of Giza. More exotic journeys have yielded similarly unexpected evocations of subjects varied as roofless tetrapylons in Syria, overpowering icescapes in Greenland, a moldering ancient coffee port in Yemen, or stone idols sinking into Southeast Asian jungles.

Not long after the millennium turned, she found herself on the coast of Ghana. After all the temples, monuments, pagodas, minarets, and Buddhas, she now confronted a grim stone portal, known as the Gate of No Return, through which untold thousands of Africans had passed en route to bondage across the Atlantic. It was a place where all the manifestations of human grandeur she had communed with in seventy countries felt demeaned by humanity's basest impulses, and she found herself bleakly wondering what our species might one day be remembered for most.

What Lynn has come to believe is the answer may surprise people familiar with the oeuvre she's amassed, but to her it's

now obvious—just as the work contained in this volume feels like an inevitable stop on her formidable journey. Her chance to articulate it came one day in the Edwynn Houk Gallery in New York, when she was introduced to one of her collectors, an insurance brokerage CEO named Alden Richards.

Richards's company, she was intrigued to learn, had a unique specialty: securing underwriting for space flights. He had been to every launching pad on Earth. They were extraordinary sights, he said: sudden bursts of monumental technology in the middle of nowhere, bristling with intricate, totemic structures. But for security reasons these were rarely photographed, if ever. They soon had an agreement: He would arrange clearance for her to visit launch sites in exchange for a print from wherever she and her camera went to interpret the human itch to break free of earthly bonds and hurl ourselves toward whatever is out there.

To contemplate outer space is to ponder our place—and role, if any—in some infinite and eternal beyond. Is that what impelled Davis to cast the Zeiss eye of her Rolleiflex, if not exactly skyward, then at those points of departure from where, for the past half-century, humans have been trying to cut trails to the heavens? Or a primal urge to embrace something yet unblemished? She wasn't sure herself, until her first trip: to Centre Spatial Guyanais at Kourou, French Guiana, for a launch of an Ariane IV rocket.

Although situated on the north coast of South America, French Guiana is officially part of France. Because the ideal

Originally, Lynn had thought her project was mainly architectural, ... But after witnessing Ariane ignite the blackness, she felt both seduced and transfigured. What humans might be remembered for most, she decided, would be freeing our terrestrial species from Terra itself.

place to overcome gravity is near the equator, using the maximum velocity of the planet's rotation to help fling things into space, this is where Europe conducts its launches. From here, the European Space Agency sends aloft everything from low-level environmental observation probes to communications satellites that hang 22,250 miles above the Earth, where their revolutions match the planet's, locking them into fixed geosynchronous orbit.

Due to restrictions, in the days before the launch Davis was allowed only a few precious minutes to approach the rocket bearing one of these—another reason, she realized, to be grateful that she used a simple hand-held camera. But on the day itself, she was dismayed to learn that the viewing stand was off-limits to nonessential personnel, and she would be forced to watch from three miles away. The launch, a night shot, was slipped fortuitously into a break between tropical storms that had drenched the surrounding forest, saturating the humid air with a rich fungal essence. From the edge of this dripping jungle, overlooking the desolate former French penal colony of Devil's Island, it occurred to Davis that the remote, secretive settings from which rockets depart were as striking as the space paraphernalia itself. For the only exposure she would get, she decided to use a normal lens instead of a telephoto, knowing that most of the image would be the dark emptiness encircling her. Pointing her Rollei in the direction of the anomalous hardware towering above the tropics as the countdown, clearly audible across the void, reached trois, deux, un… décollage! —she opened her shutter and hoped for the best.

Originally, Lynn had thought her project was mainly architectural, somehow portraying through the elaborate geometrics of the space industry what and why it was, and perhaps hinting at where it might lead. But after witnessing Ariane ignite the blackness, she felt both seduced and transfigured. What humans might be remembered for most, she decided, would be freeing our terrestrial species from Terra itself.

———

In 2009 Russia will start using equatorial French Guiana as well, increasing the payload capacity of its Soyuz rockets by more than a metric ton. The coastal setting offers a further benefit: launches over water minimize disaster in the event of a failure. That alone, Lynn Davis learned, would be an improvement over what has happened in Kazakhstan, the former Soviet republic where, since Sputnik 1, Russians have reached for space. Rockets departing the Baikonur Cosmodrome typically sent their jettisoned stages crashing to the steppes and forests downrange from the site. At times these contained unspent fuels such as hydrazine, a carcinogen blamed for a rash of deformations and premature births in eastern Kazakhstan during the 1950s and 1960s.

At nearly 3,000 square miles, Baikonur is the world's largest launch site. For Davis, gaining access to it sometimes felt as byzantine as a Cold War spy thriller or latter-day drug deal, including a sudden demand en route

Places where energy had literally gushed from men and machines alike, now abandoned wrecks straight out of Ozymandias's shattered kingdom. What had felt all her life like humankind's future was already disappearing amid weeds cracking their way through concrete pads three feet thick.

for thousands of dollars to be wired from Paris, followed by days sitting alone in Baikonur's sole hotel, where toilet paper wasn't provided, waiting for a Moscow contact who never appeared. Once she finally talked her way in, however, she found the Russians more accommodating than she had dared imagine. Here a person could go right up to a spacecraft headed for the pad and pat its booster's frigid, liquid-oxygen-filled belly, or stare directly into the great maw of a Soyuz TMA-3 engine's thrusters. The place had a wild, Buck Rodgers feel. Compared to Ariane, which resembled an elegant pencil perched atop a stick of dynamite, a Russian capsule she saw reminded her of a Jeep riding a bomb. Most amazing, though, was finding the history of the Soviet-Russian space program littered across the landscape: everywhere were rusting, abandoned gantries and other techno-detritus being reclaimed by the vast steppe's vegetation.

This tug-of-war between the Earth and space opened a new layer of meaning that ultimately defines this body of work. Roaming Baikonur—and later, Kennedy Space Center, Cape Canaveral, and Vandenberg and Edwards Air Force Bases in the United States—Davis would encounter staggering structures and extravagantly detailed mechanisms whose forms embodied the quintessence of modern science. They provided continual visual awe and fascination that reached a nearly reverent climax during a few priceless moments in the presence of two of the most exquisite handmade items she'd ever seen: the future Mars rovers, Spirit and Opportunity, attended by white-gowned women technicians

sewing golden wires through which instructions from millions of miles away would fire their neurons.

But what moved Lynn Davis most was finding, scattered over Baikonur's steppes or the desert at Edwards, remains of platforms once robust and teeming with engineers, places where energy had literally gushed from men and machines alike, now abandoned wrecks straight out of Ozymandias's shattered kingdom. What had felt all her life like humankind's future was already disappearing amid weeds cracking their way through concrete pads three feet thick. Blast pits that had withstood molten rocket fuel were succumbing to tiny flowers; with unexpected beauty, a rusting Vandenberg gantry had already reverted into a Mayan ruin hulking over rising foliage. Here on Earth, it turns out, biology still rules—and will until the Sun expands and turns our world to ash, billions of years hence.

Might biology rule in space as well?

When he's not at the NASA's Jet Propulsion Laboratory or in Europe with colleagues involved with the Cassini probe, for which he analyzes data gleaned from the surface of Saturn's moon Titan, Jonathan Lunine is a planetary scientist and physicist at University of Arizona. But in recent years he's added the title astrobiologist: a scientist bent on examining every available shred of planetary and stellar chemical evidence to determine if anything else out there is alive.

It's a tantalizing question, fueled by sheer fascination (and, for some, the slender hope that there might be someplace else for us to go if we use up the planet we're on). Whatever drives us to know, it will take technology to find out, and very likely a combination of technology and biology to keep us engaged in a process that human evolution—physical, intellectual, spiritual, or inseparably all—began long ago. Technologies that emerged from space programs have already changed life on Earth in stunning, unpredictable ways, ranging from the use of Velcro to seamless pan-planet telecommunications, to global positioning satellites that have literally reoriented us. But, says Lunine, much more than artful new devices is at stake.

The most immediate, compelling argument for space-based studies, he tells me, echoing astronomer Sydney Barnes, is that they may prove indispensable to our survival. "There's simply no better vantage point than up above to determine precisely what climate change is doing down here."

To muster the will to face a warming world and other twenty-first century urgencies, we have to also keep on living and learning, as we've always done. Although manned space ventures by various nations over the next two decades may not amount to much more than retracing our forty-year-old steps to the moon, unmanned projects will increase our knowledge in ways whose meaning remains to be discovered. Scheduled for 2013 is the launch of the infrared James Webb Space Telescope. Far more powerful than Hubble, it will hang in space a million

miles away to avoid heat contamination from Earth and the moon, allowing it to see the most distant and fastest moving objects in the cosmos—objects so far and fast that their light has shifted well beyond the visible spectrum, into the infrared: by definition, the oldest things in the universe. Unlike Hubble, which just sees galaxy after galaxy, JWST will peer back before the first galaxy formed, at clumps of the primordial stardust from which we are all composed.

It will have been preceded in 2009 by a NASA launch of Kepler, the biggest camera ever sent into space, to search 100,000 stars in the Milky Way for Earth-like planets. "Should they prove abundant," says Jonathan Lunine, "inevitably we'll decide to aggressively study their atmospheres and to see if they have water." Beginning in 2011, Lunine will also be sifting the data from a new pair of Mars rovers, bigger and heavier than Spirit and Opportunity, laden with instruments designed to test whether any organic molecules we've detected there were formed by living processes.

Perhaps these irresistibly interesting things may never prove practical—distance, logistics, or incompatibility with our lifeform may thwart not only human colonization beyond Earth, but even communication with anything extraterrestrial. Yet we still seek to know them. The urge to explore over the horizon, including beyond our planet's limits, says Lunine, has always been a source of inspiration to the next generation of humans.

"There's a visceral, nonviolent response within us to do so, and it's always generated new knowledge. Even if we don't use it immediately, new knowledge is forever. Eventually it changes something."

"Sometimes," agrees stargazer Lynn Davis, "I think that this whole thing on Earth is really about preparing ourselves to go out there. It may be our true Manifest Destiny."

PLATES

GEMINI NORTH OBSERVATORY

MAUNA KEA, HAWAII

PHOTOGRAPHED 2005

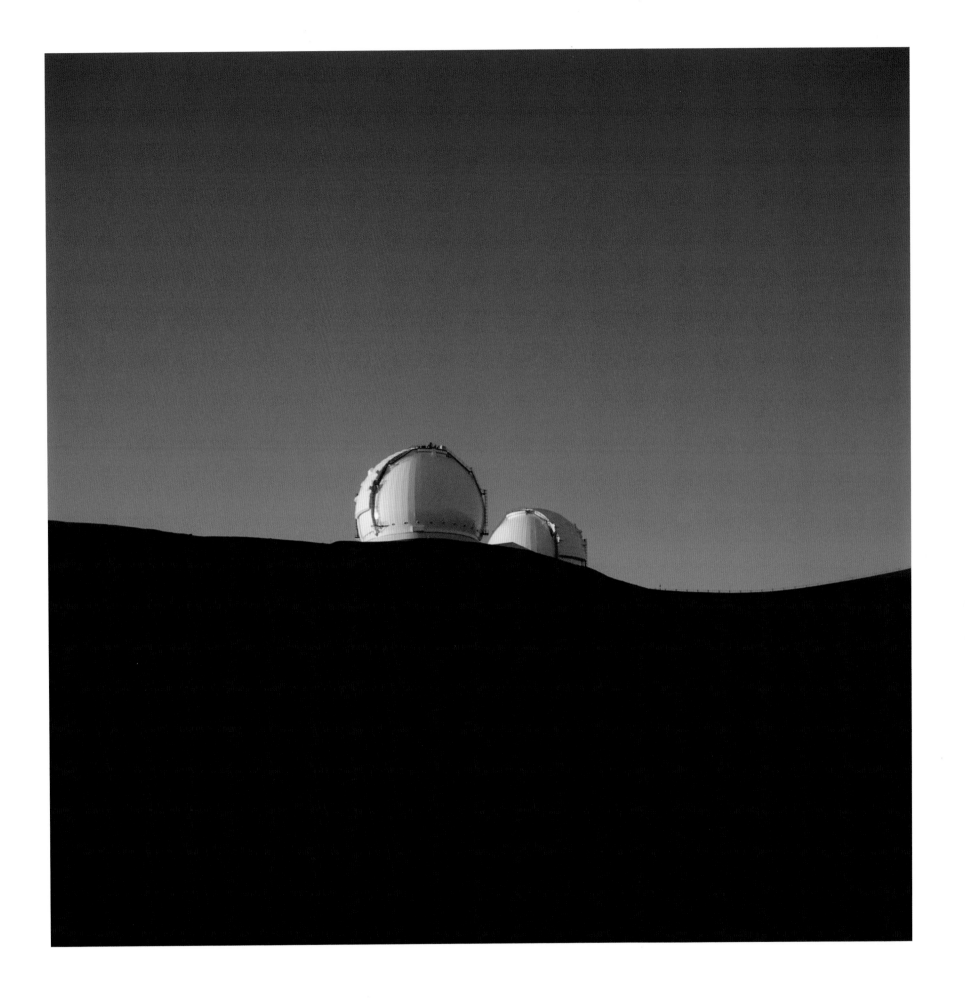

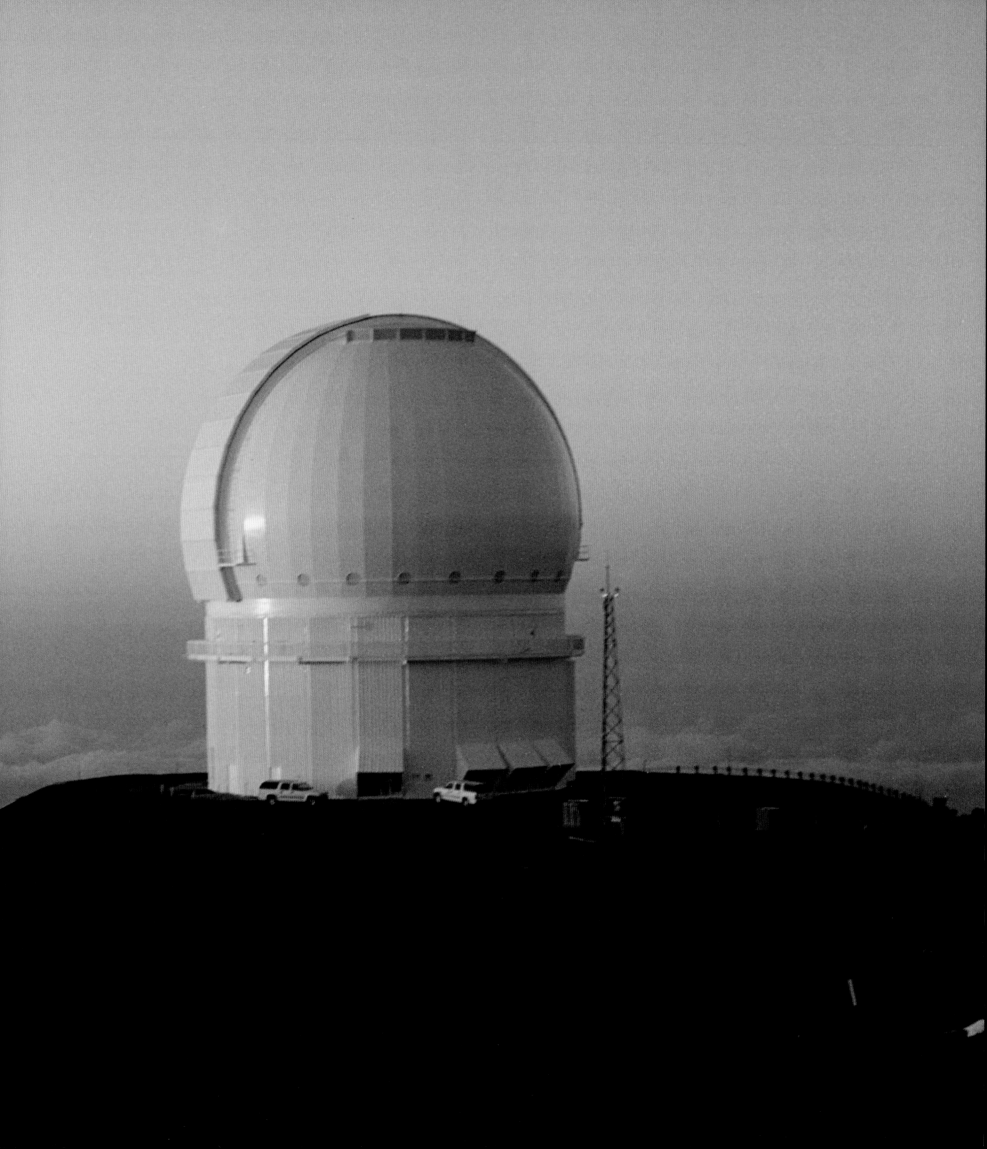

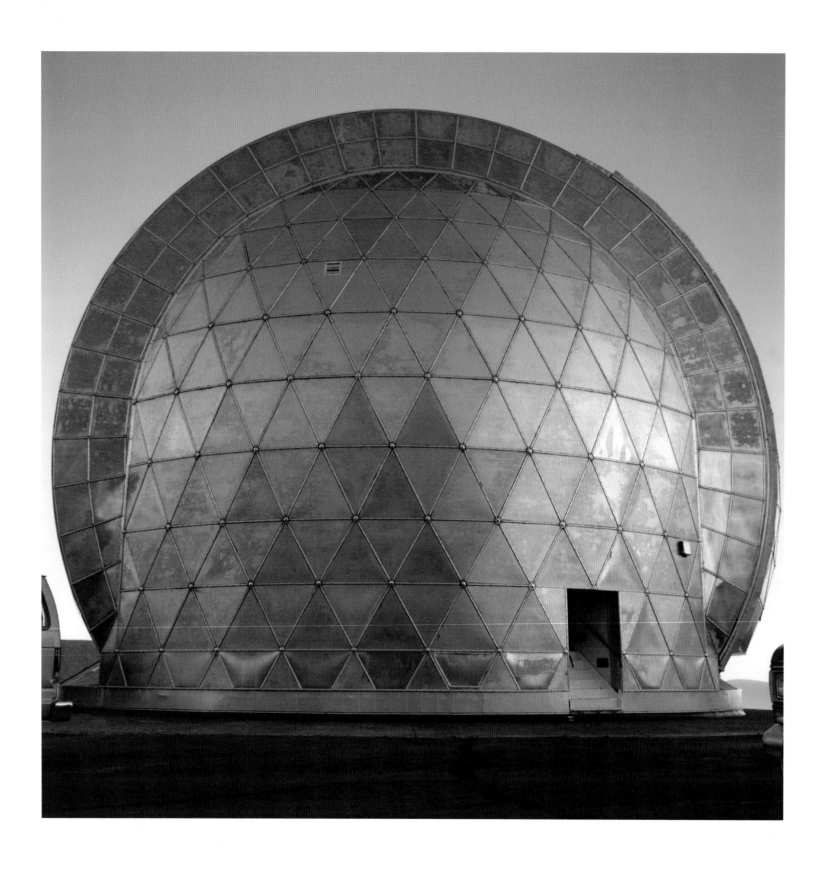

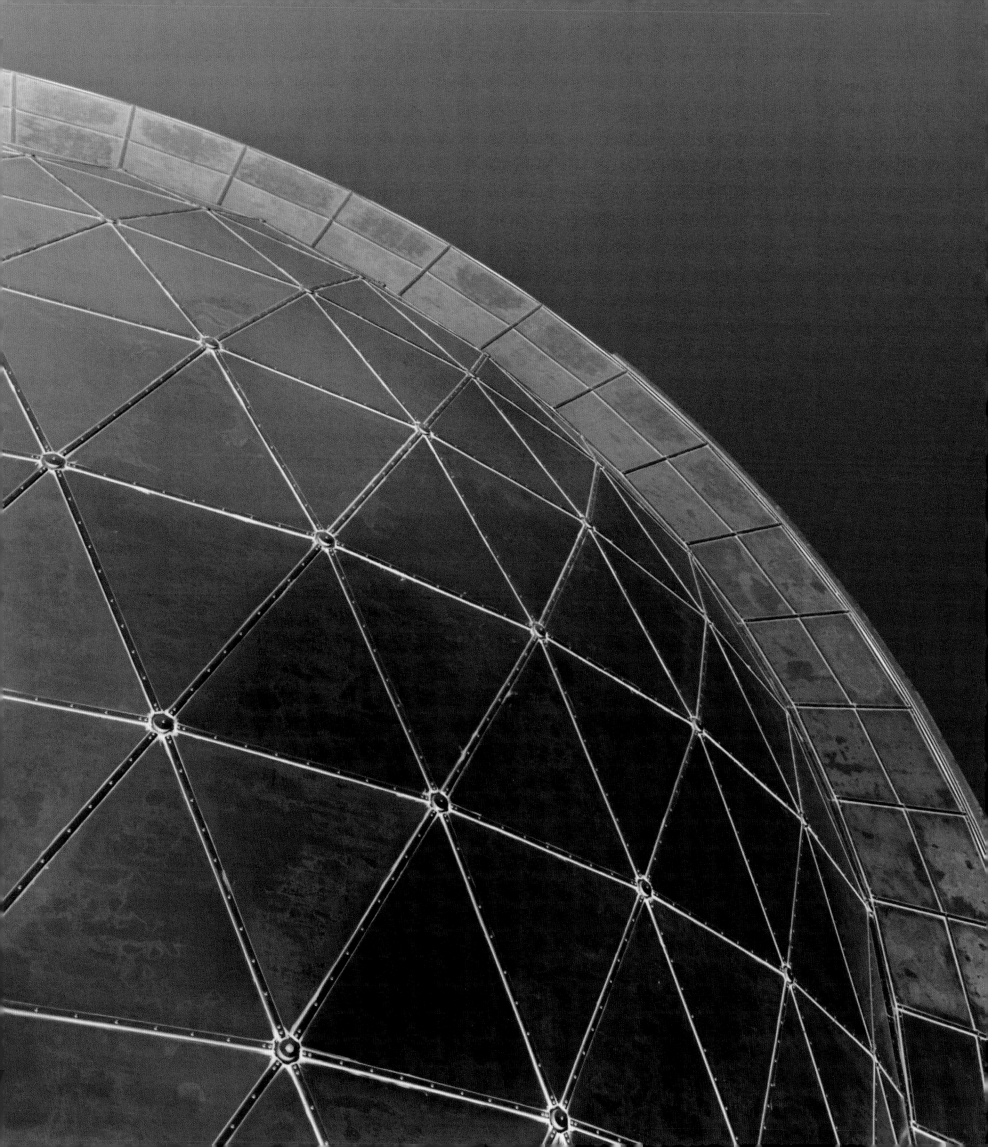

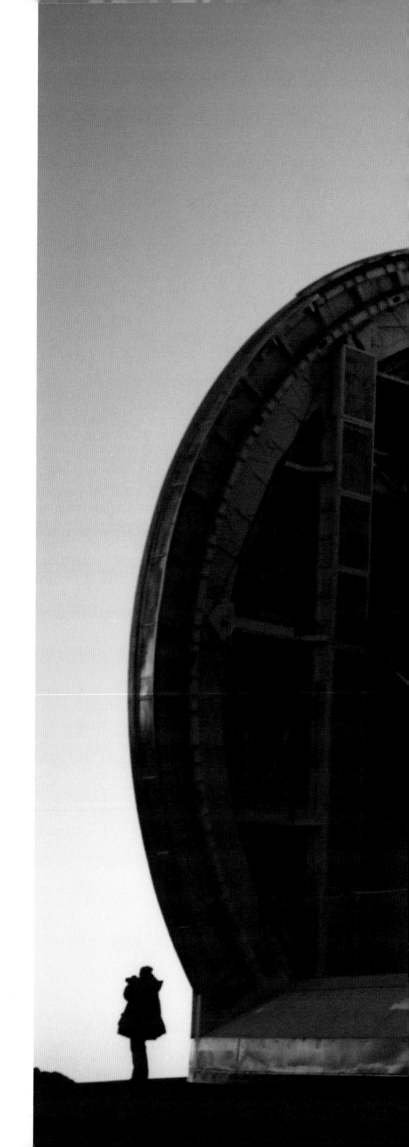

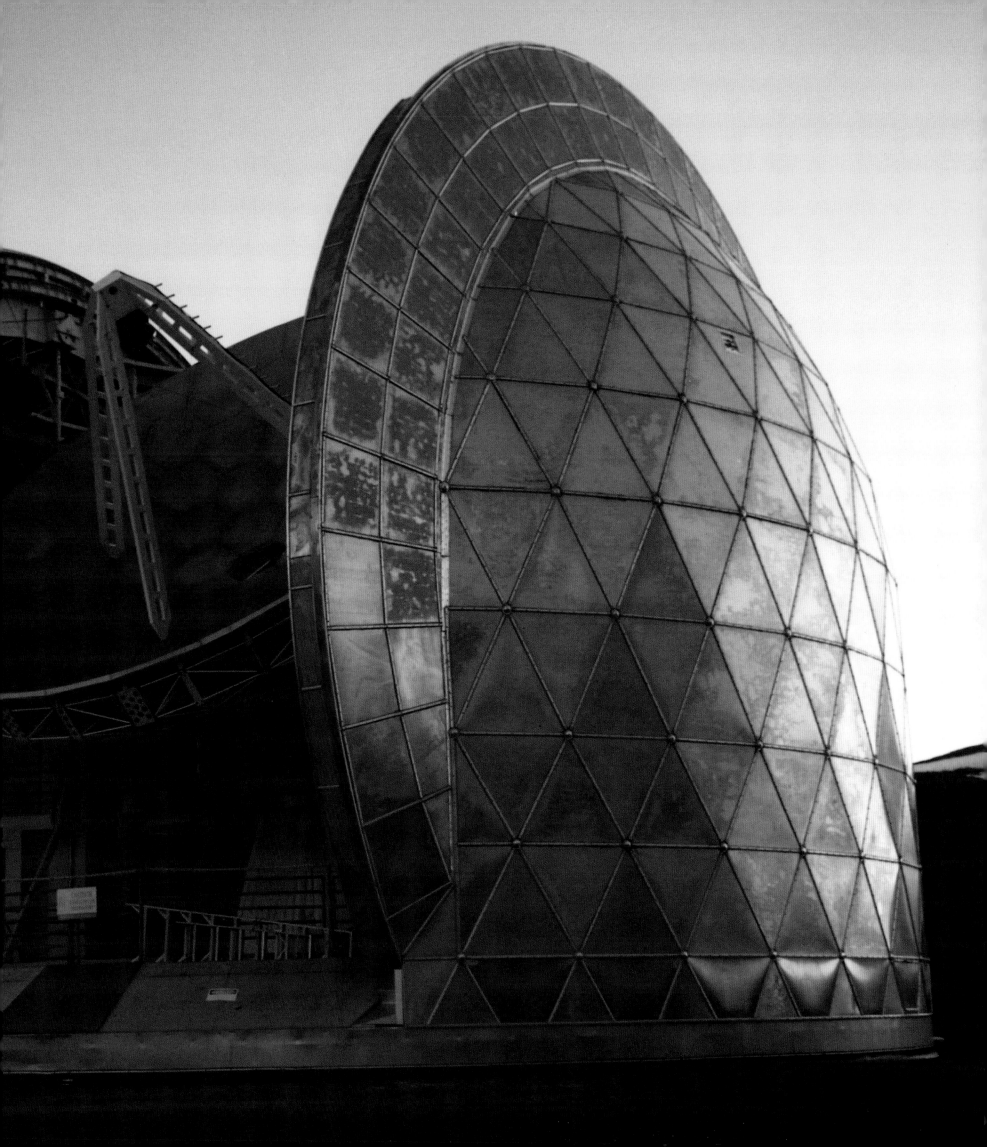

CENTRE SPATIAL GUYANAIS

KOUROU, FRENCH GUIANA

PHOTOGRAPHED 2005

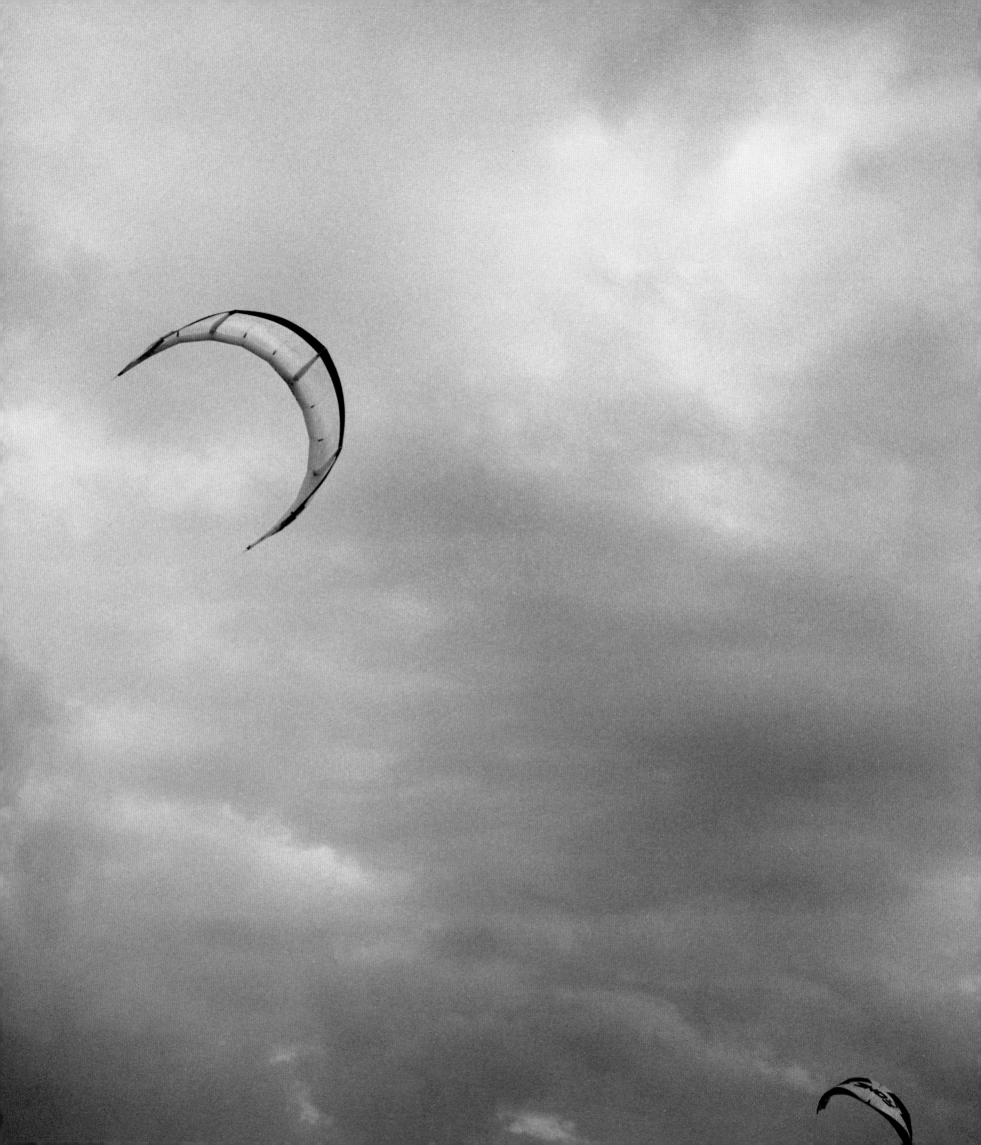

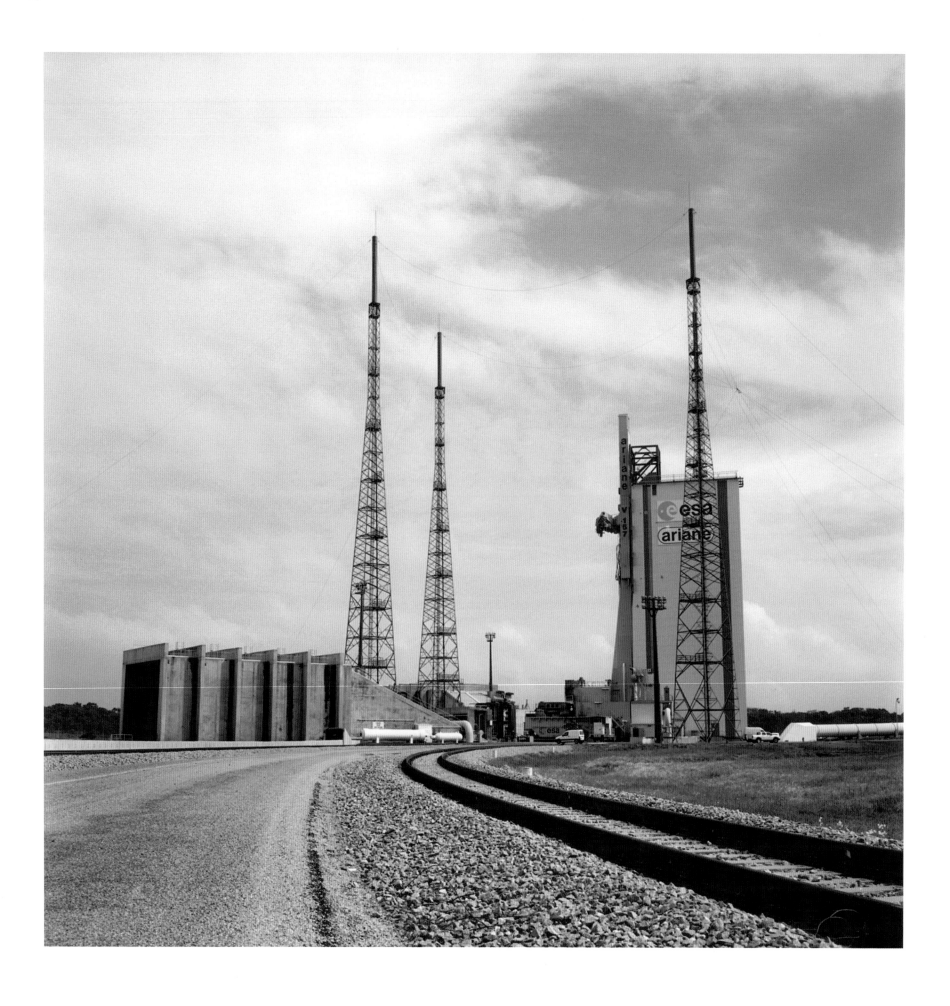

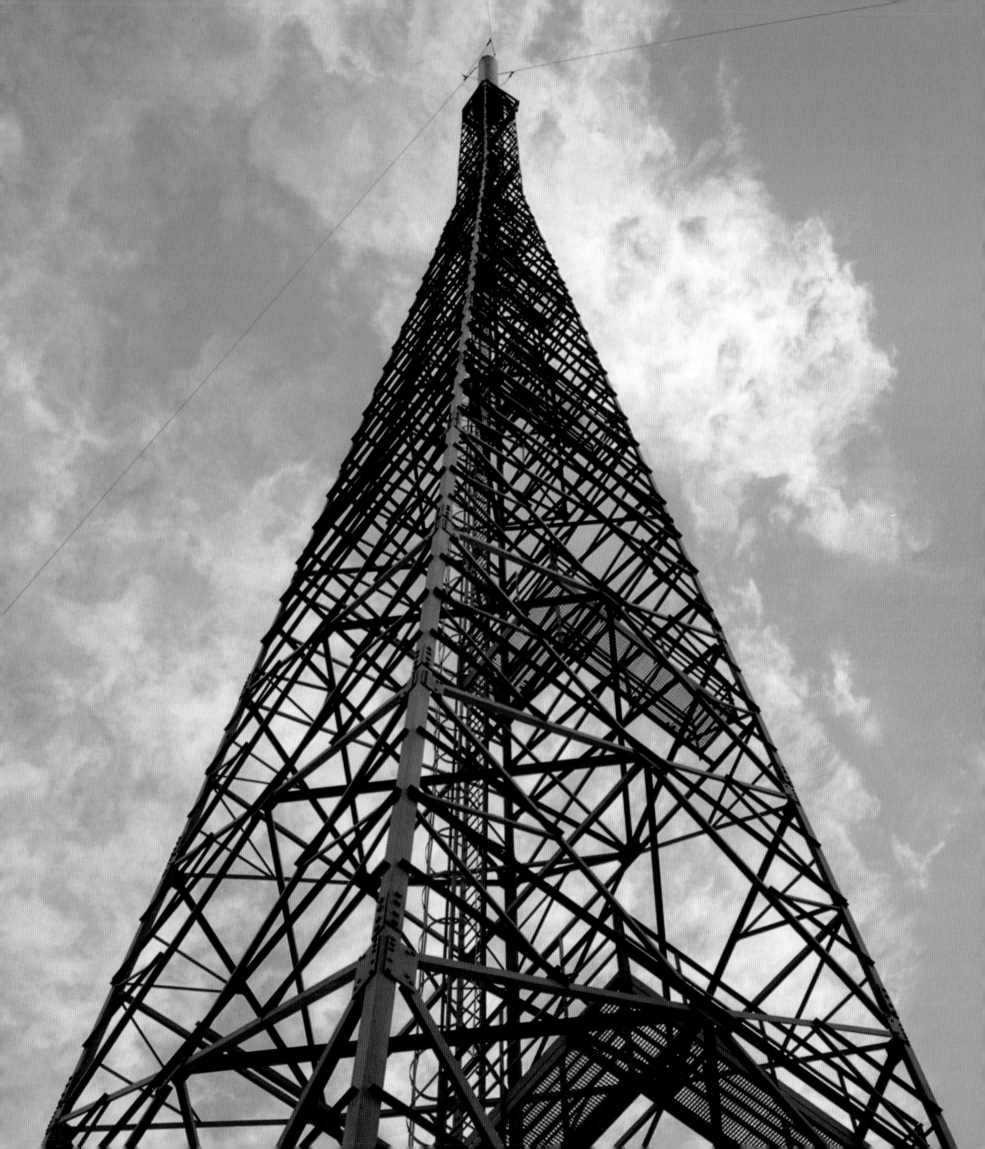

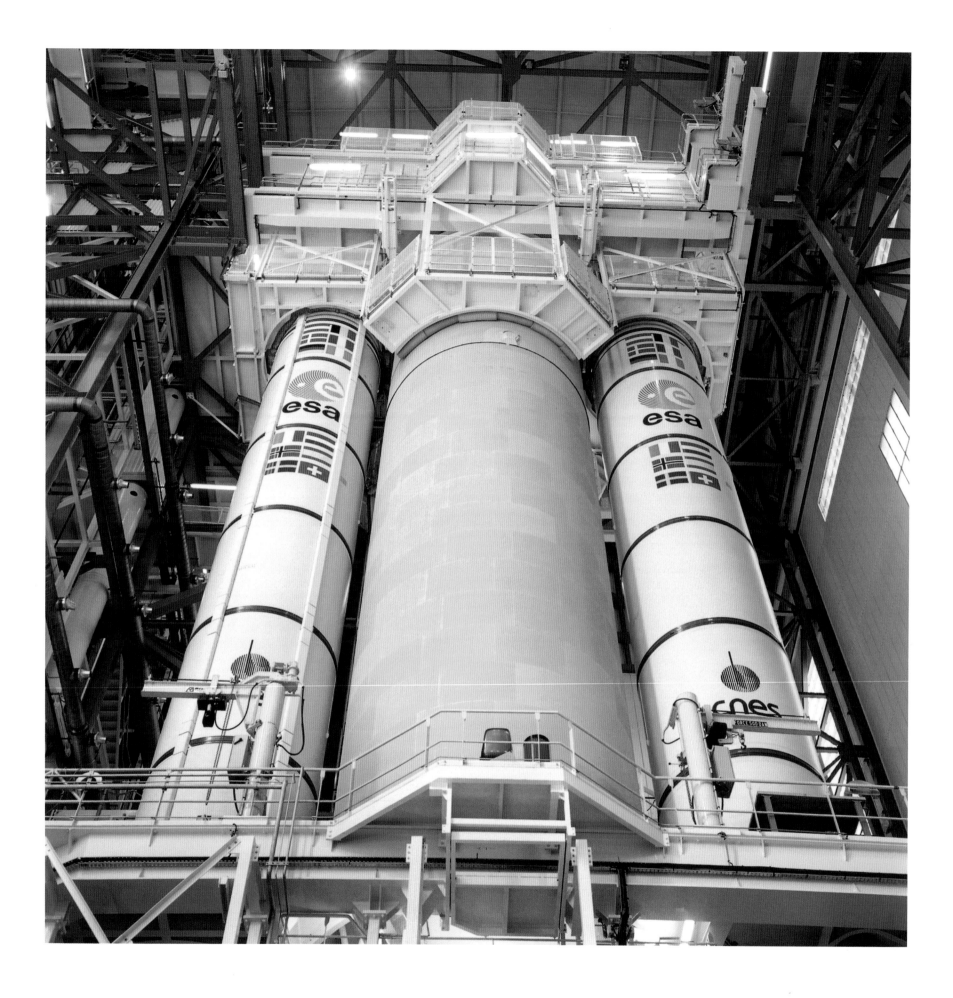

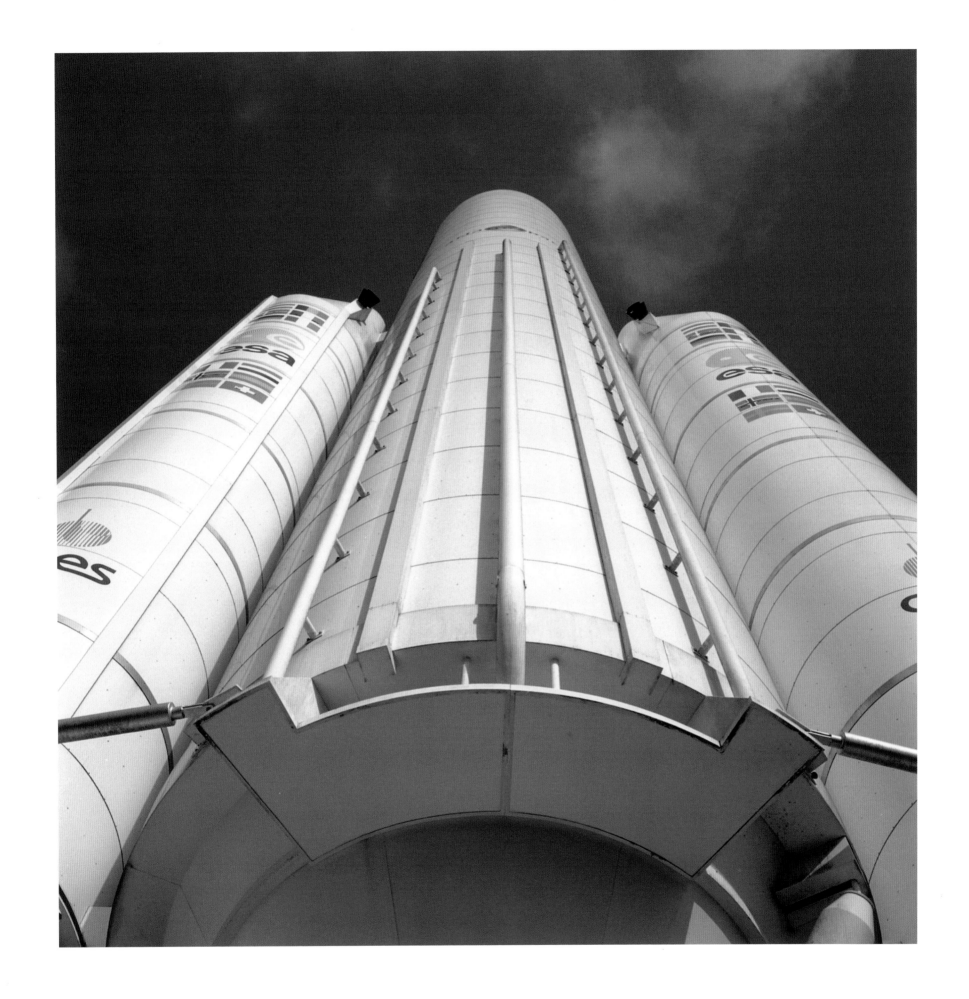

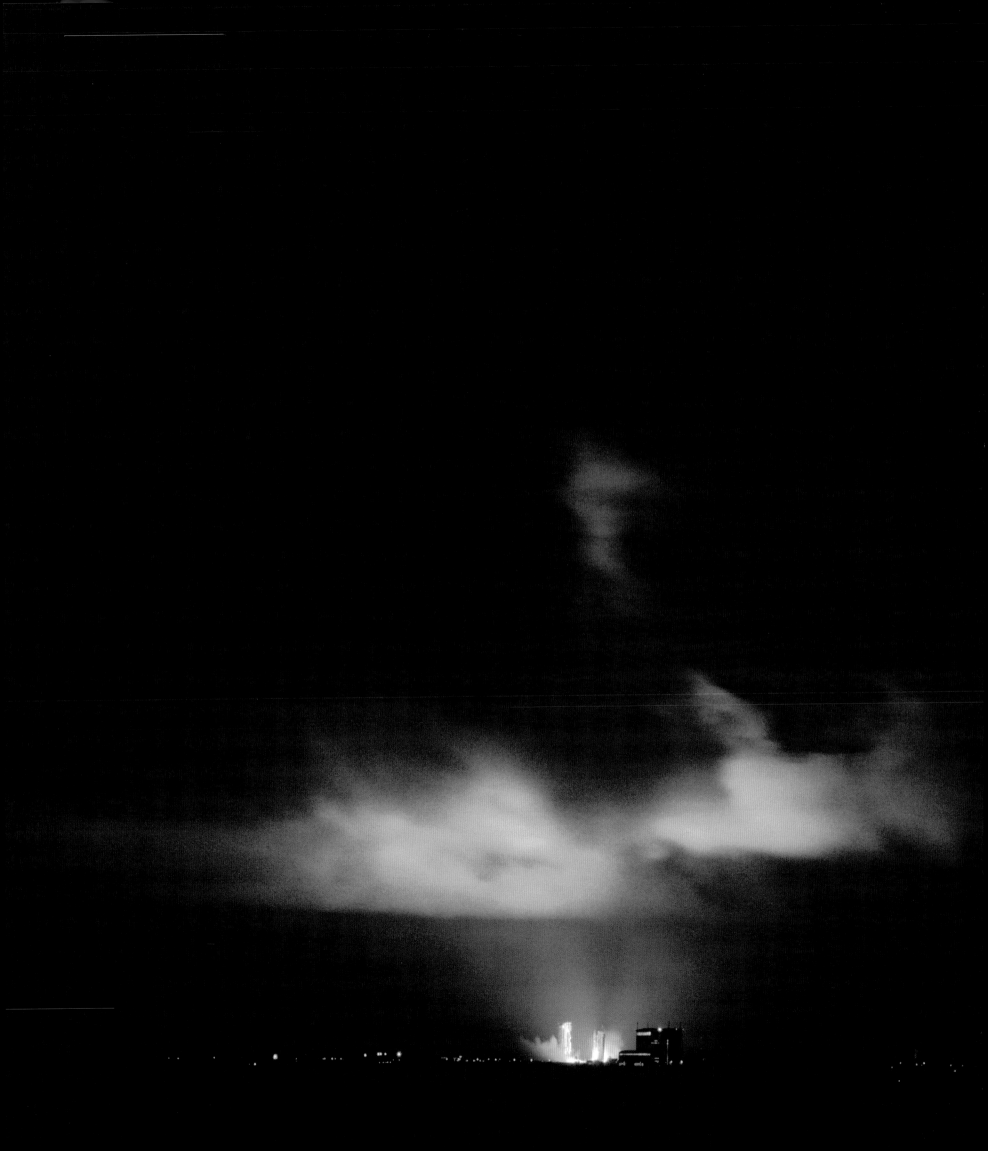

BAIKONUR COSMODROME

BAIKONUR, KAZAKHSTAN

PHOTOGRAPHED 2005

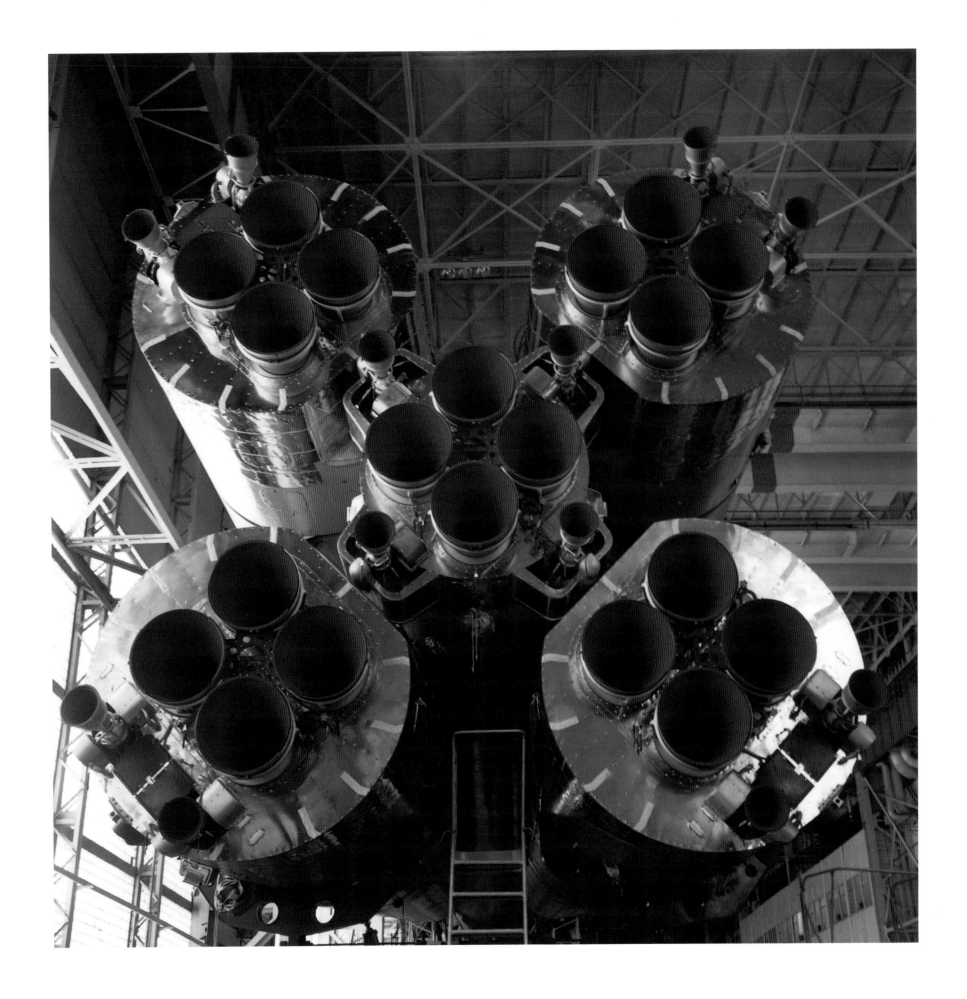

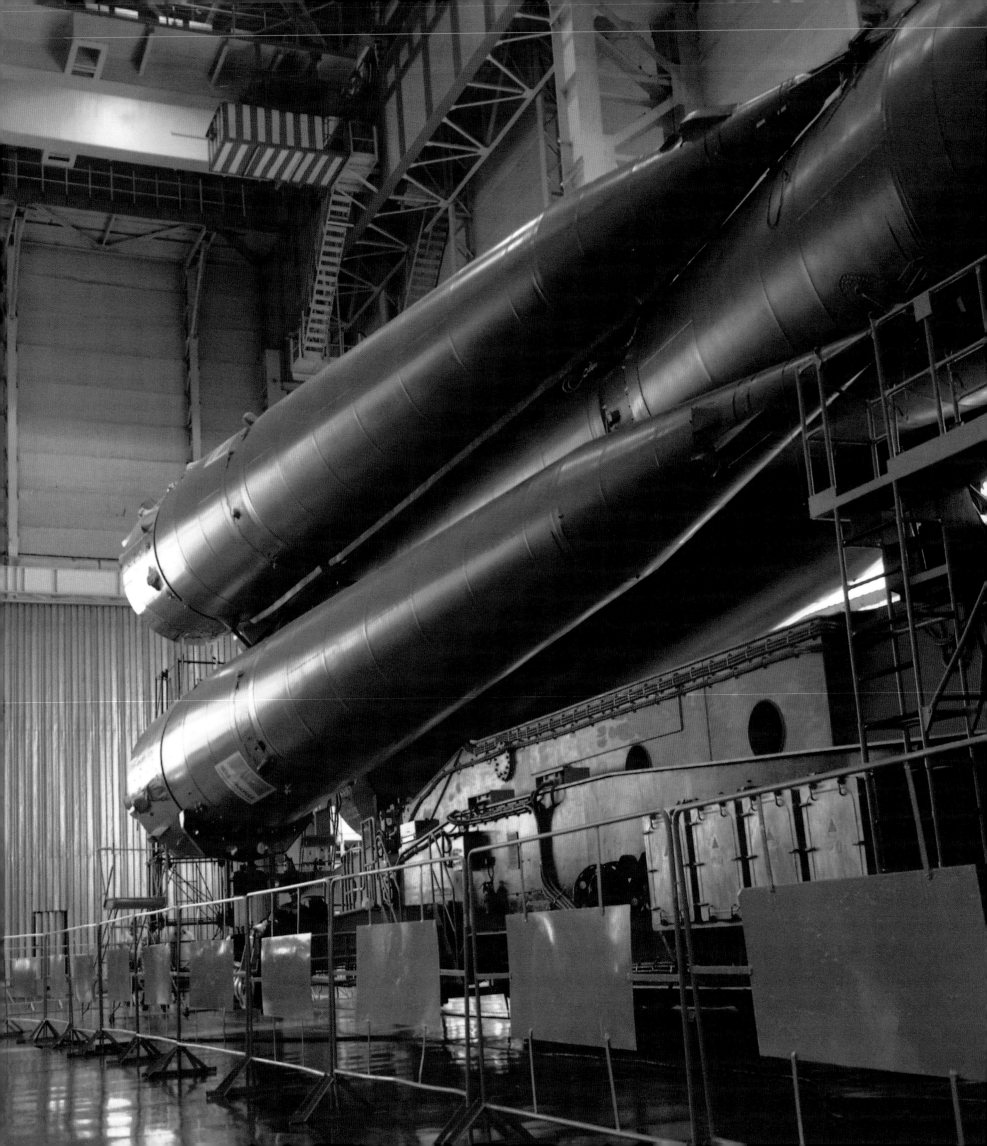

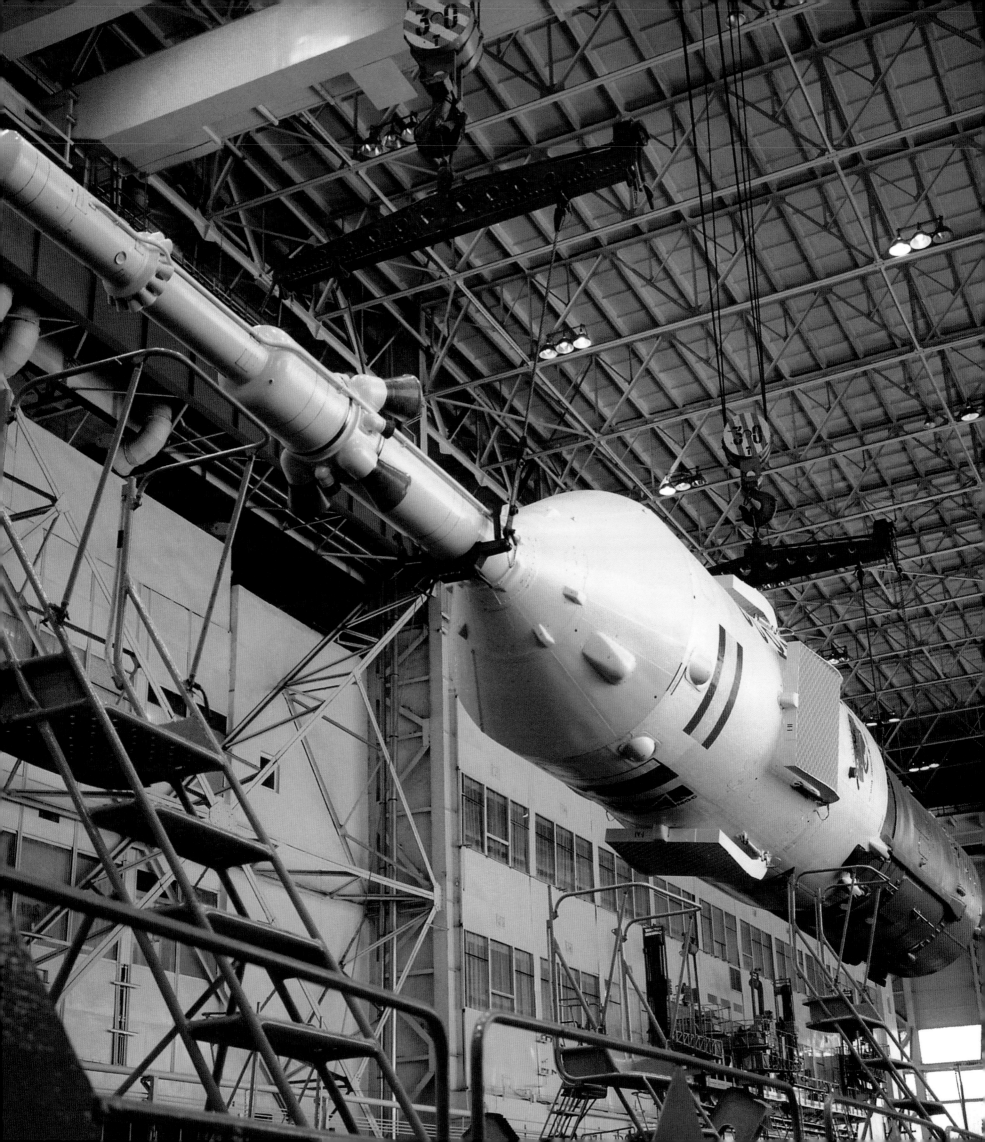

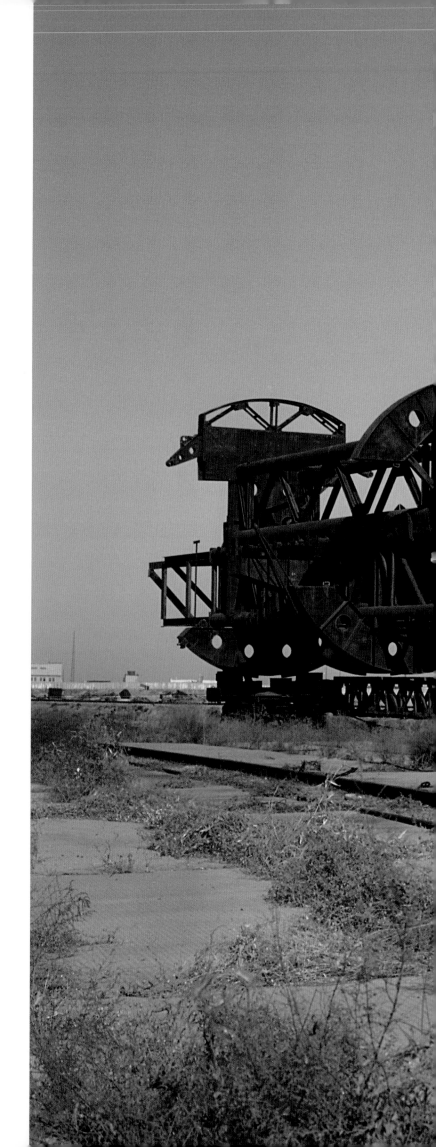

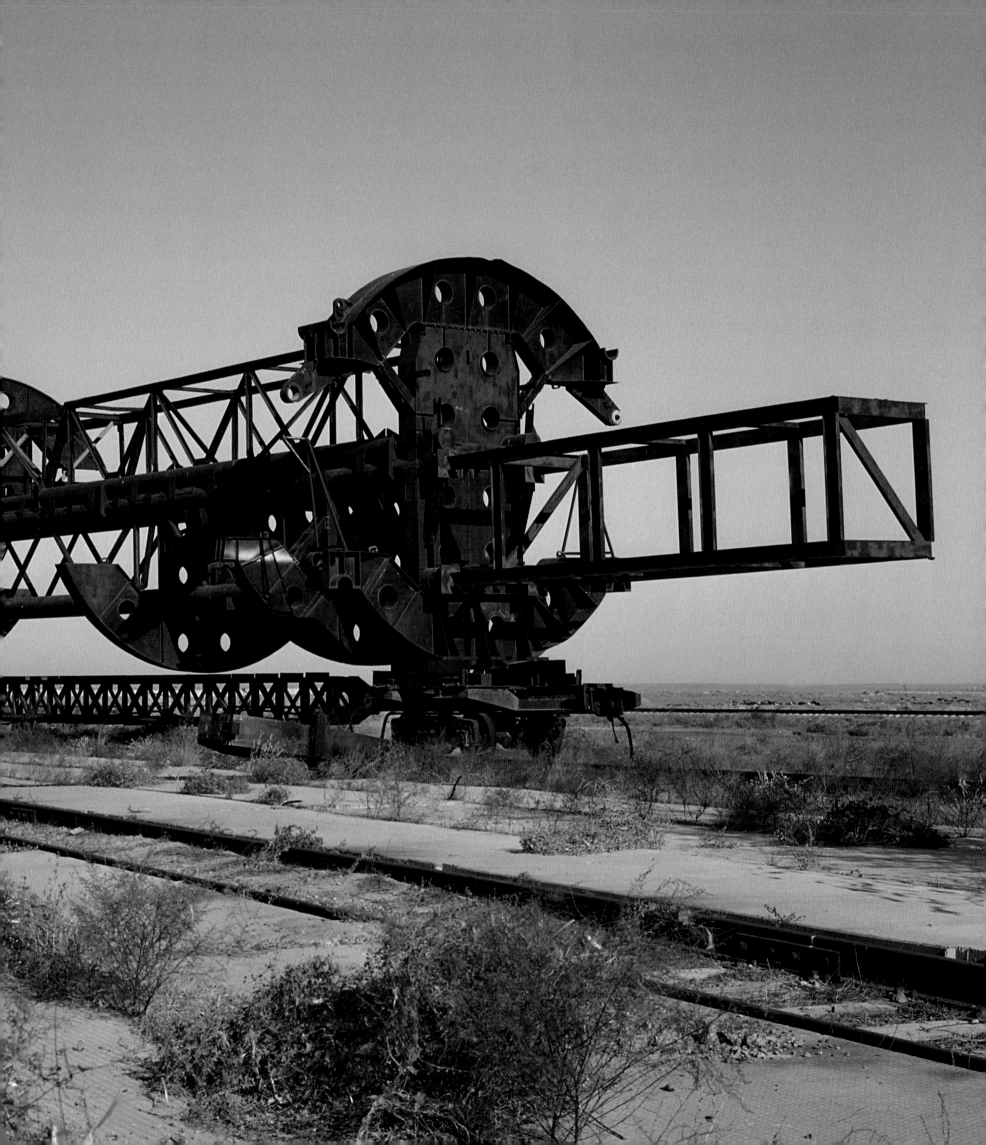

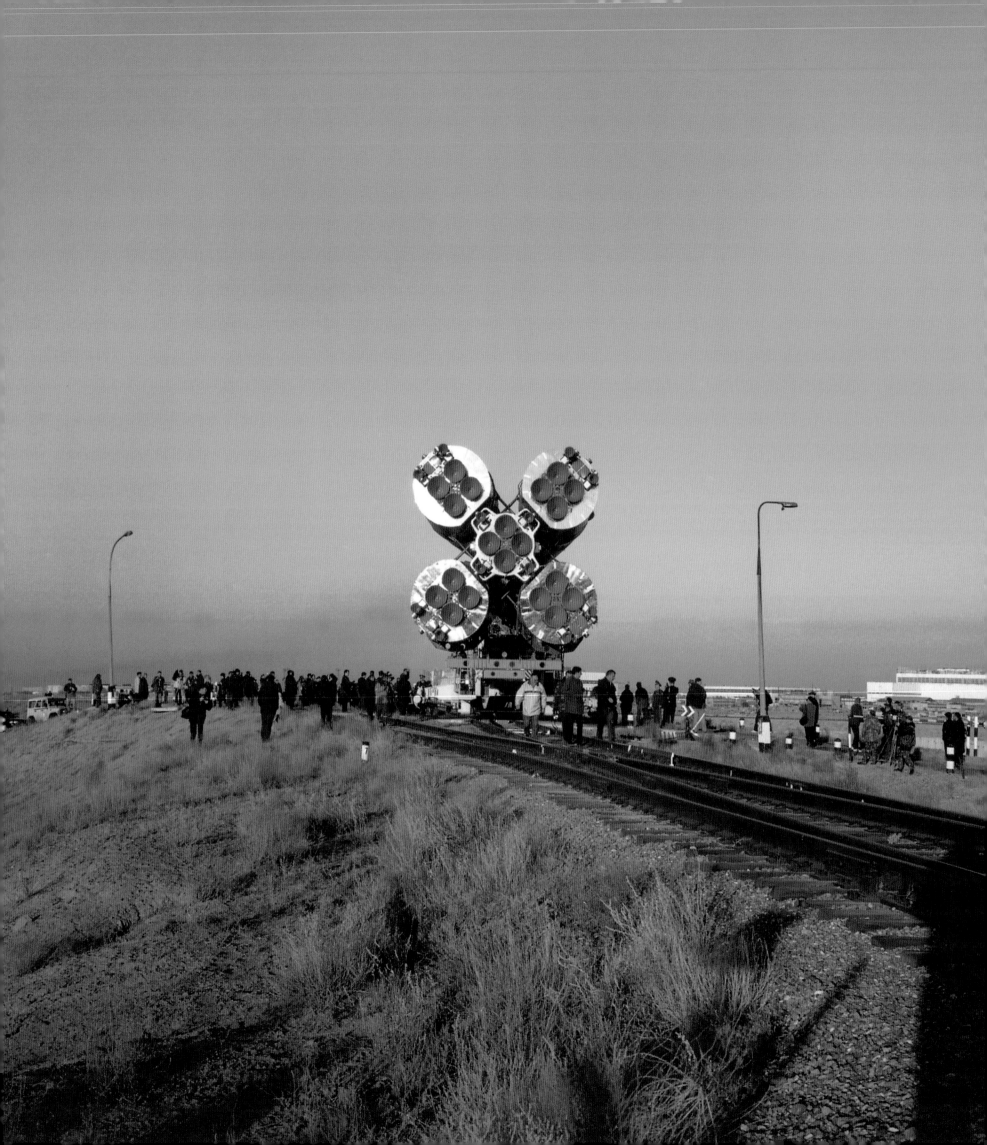

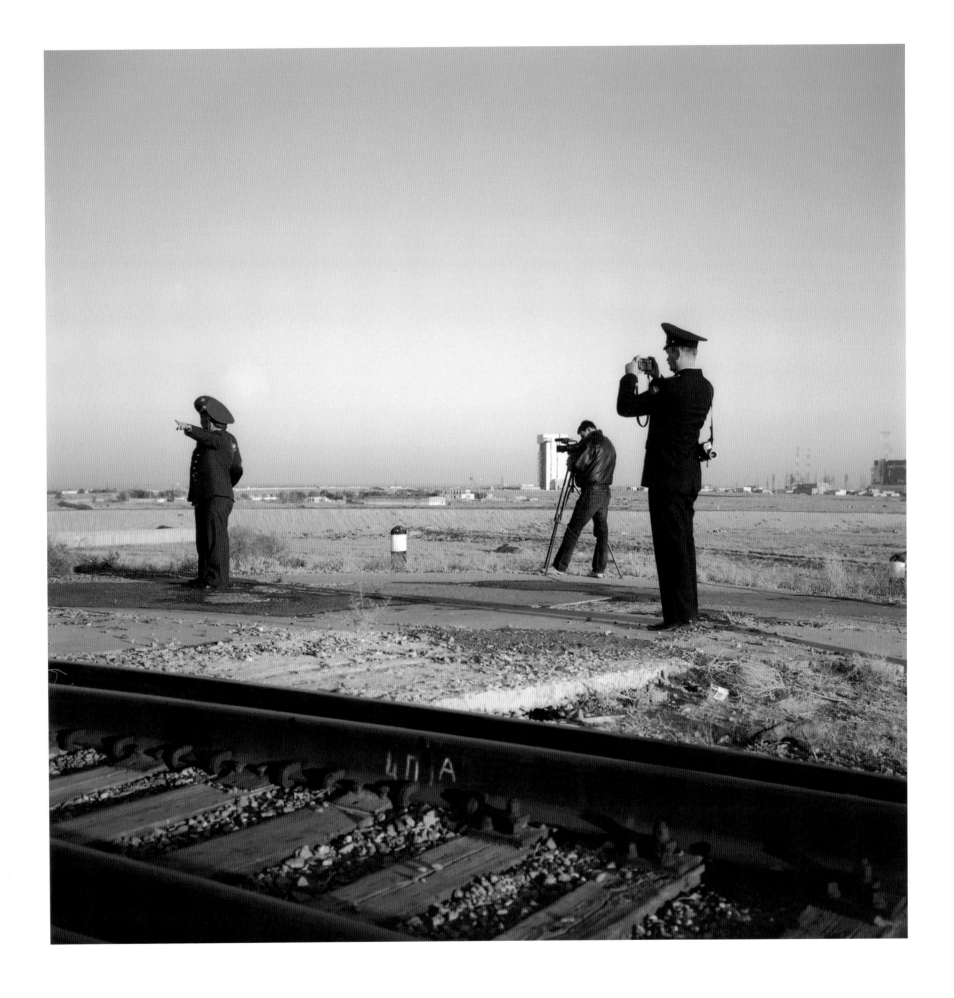

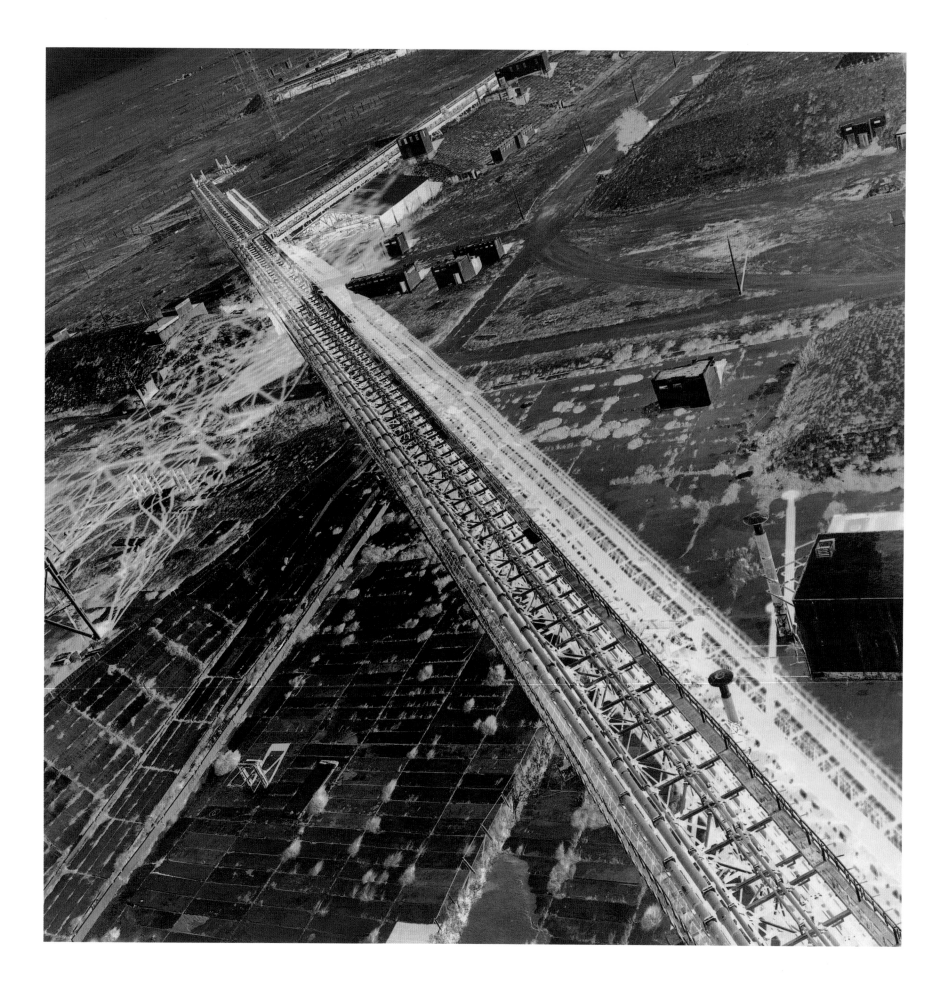

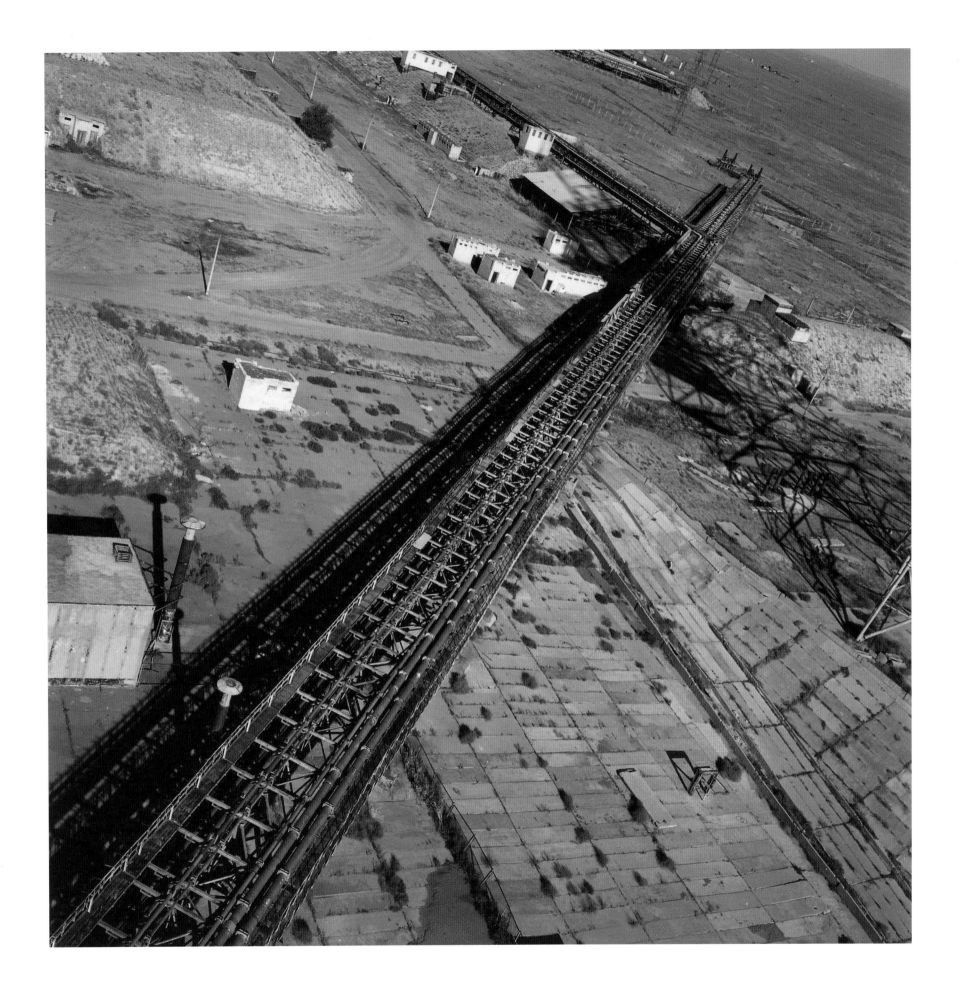

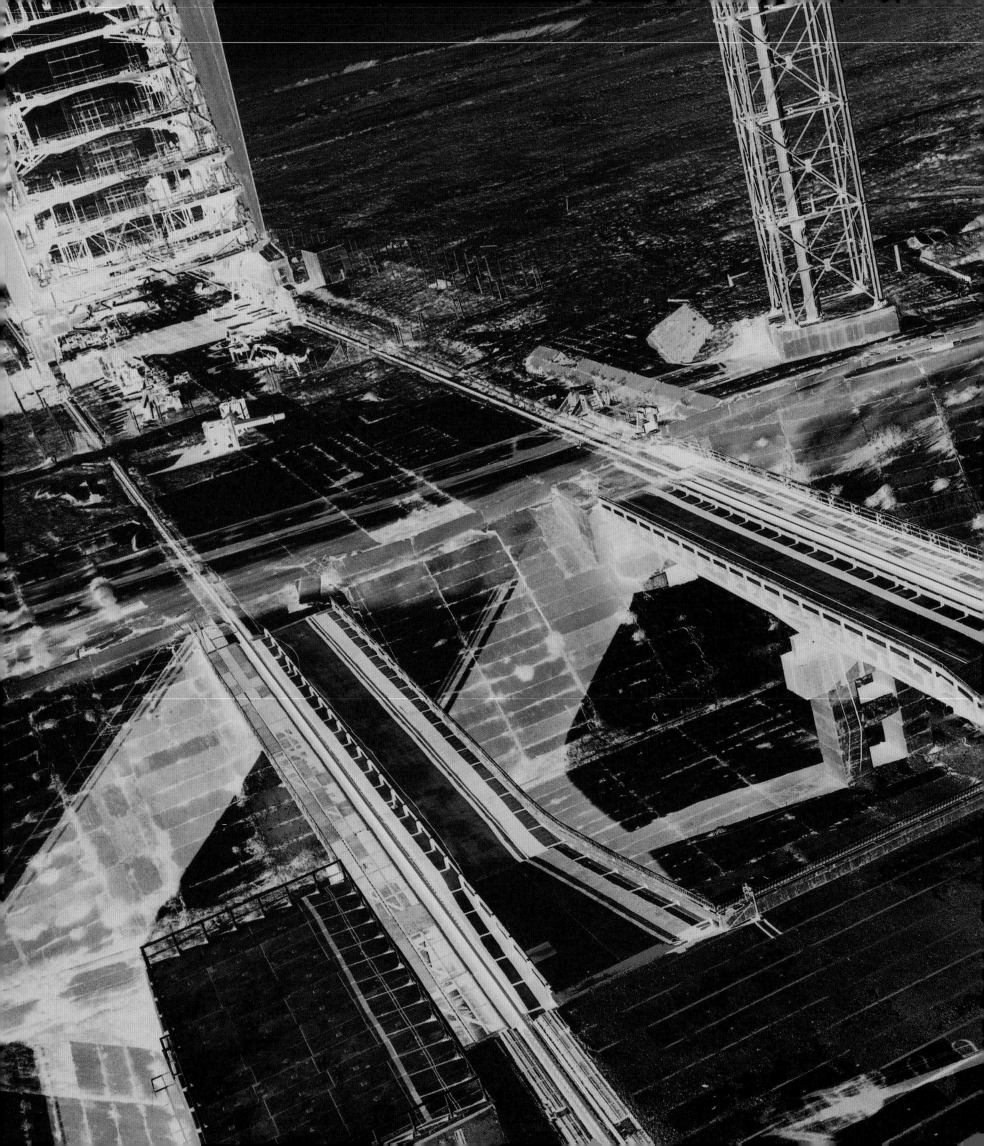

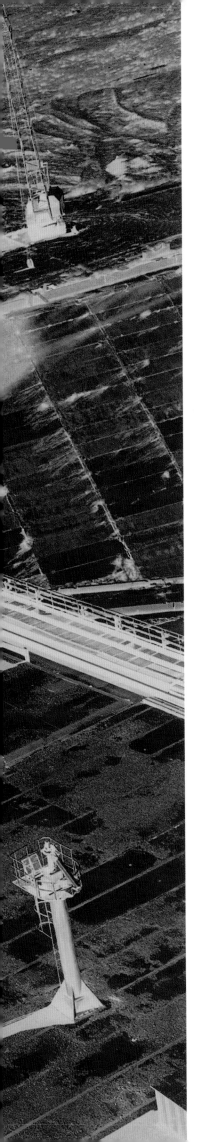

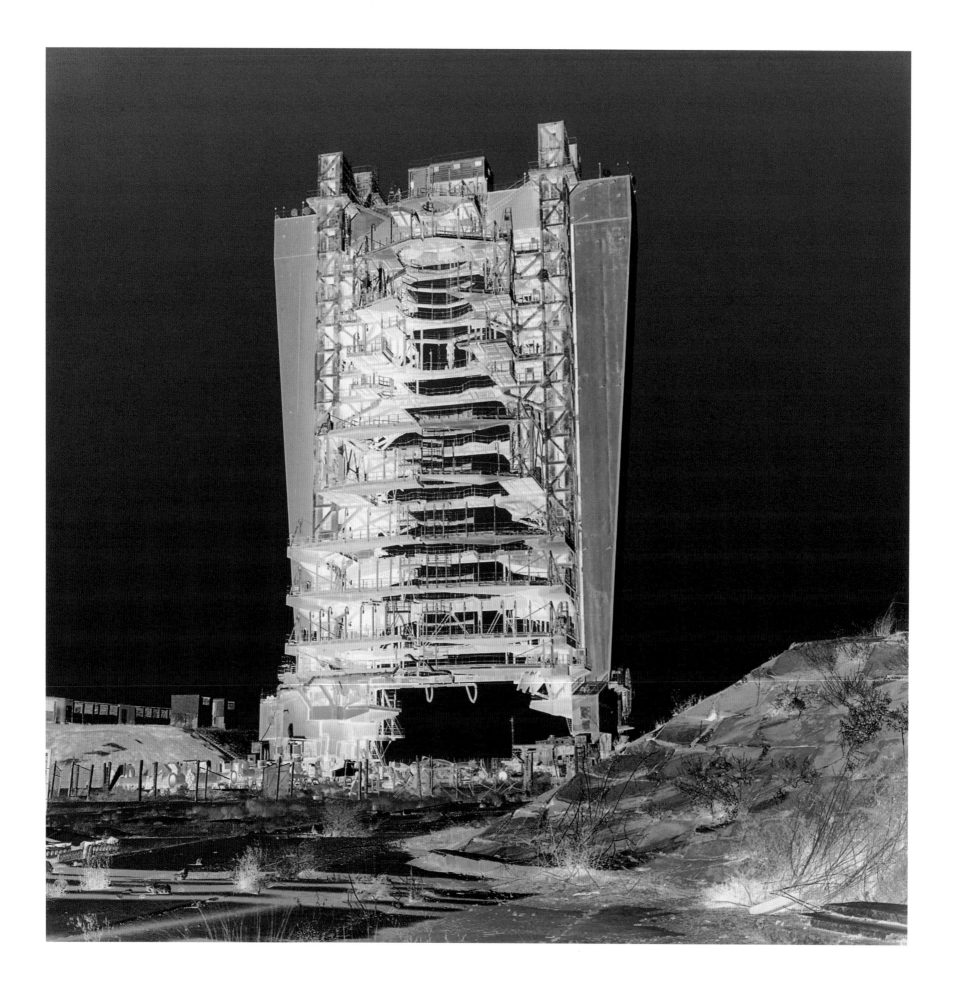

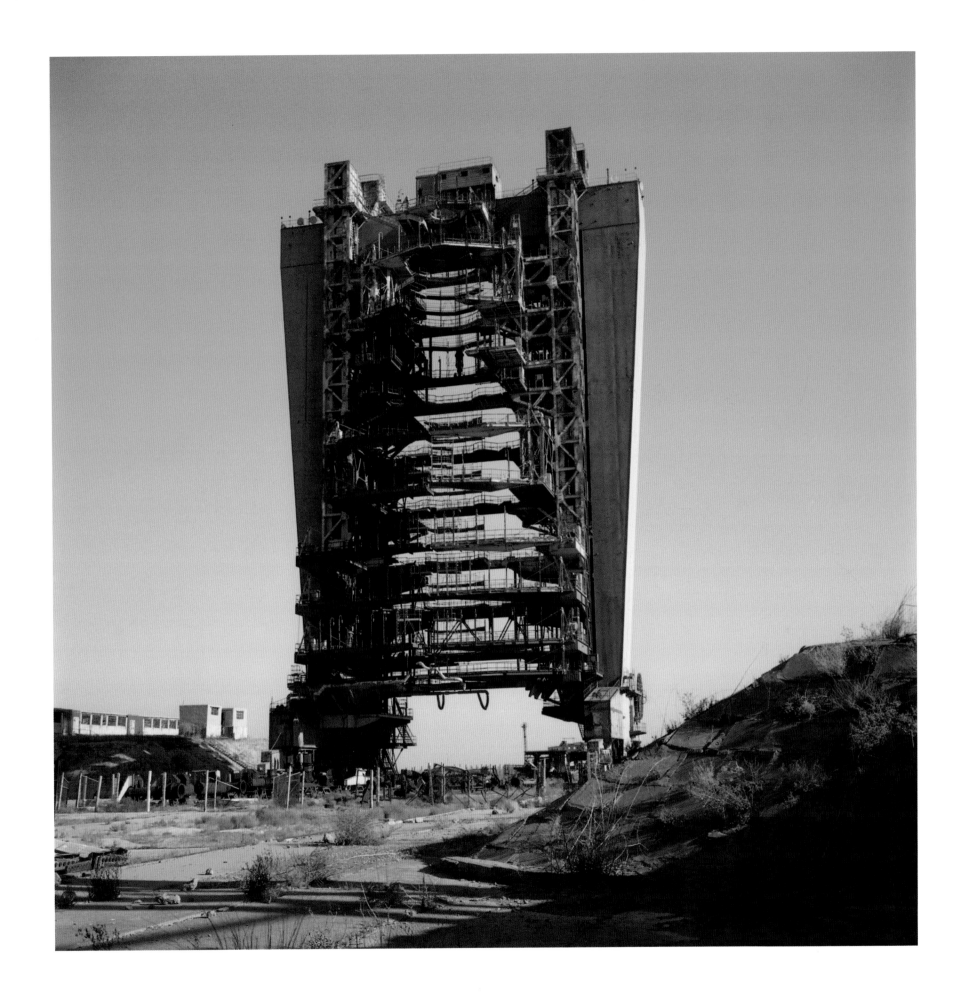

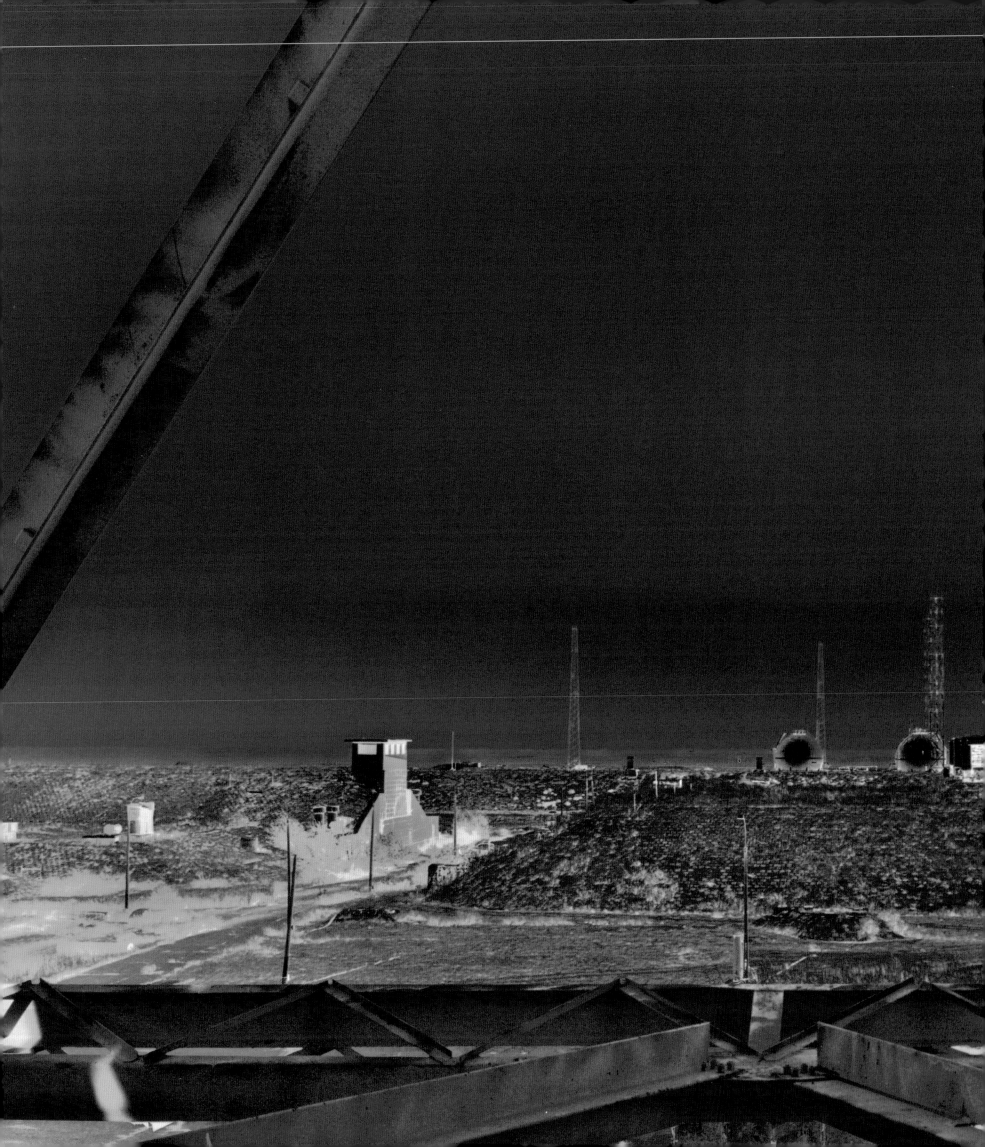

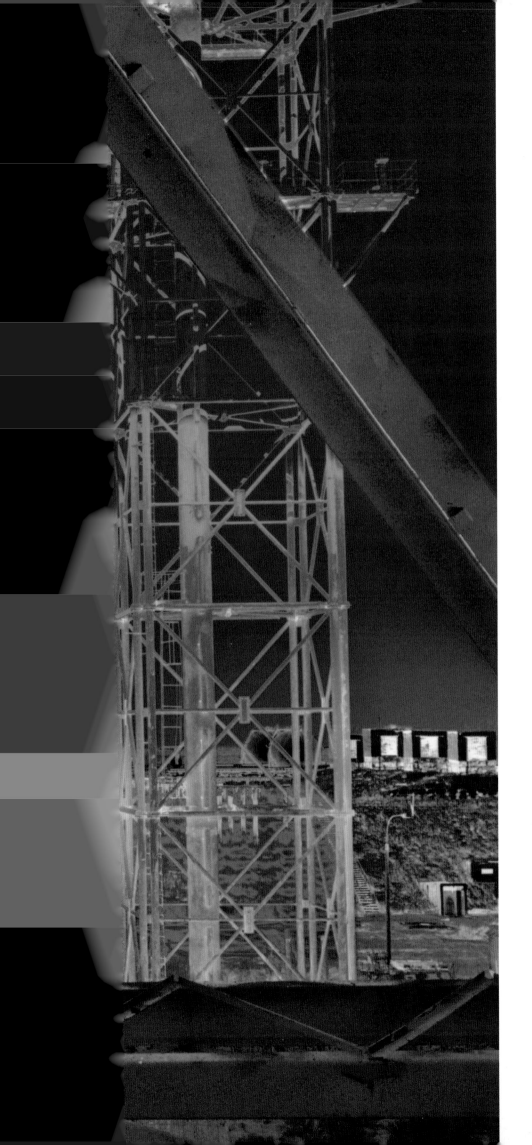

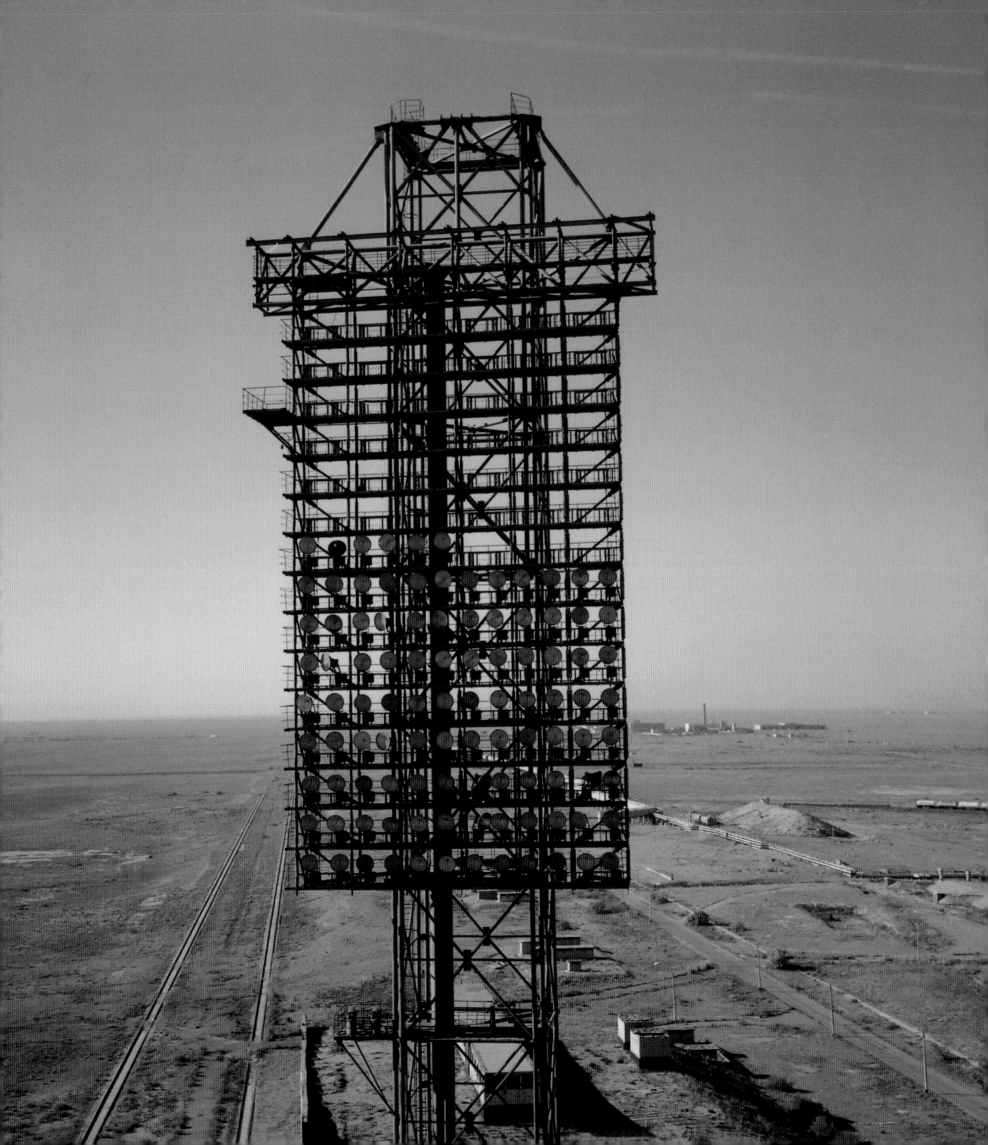

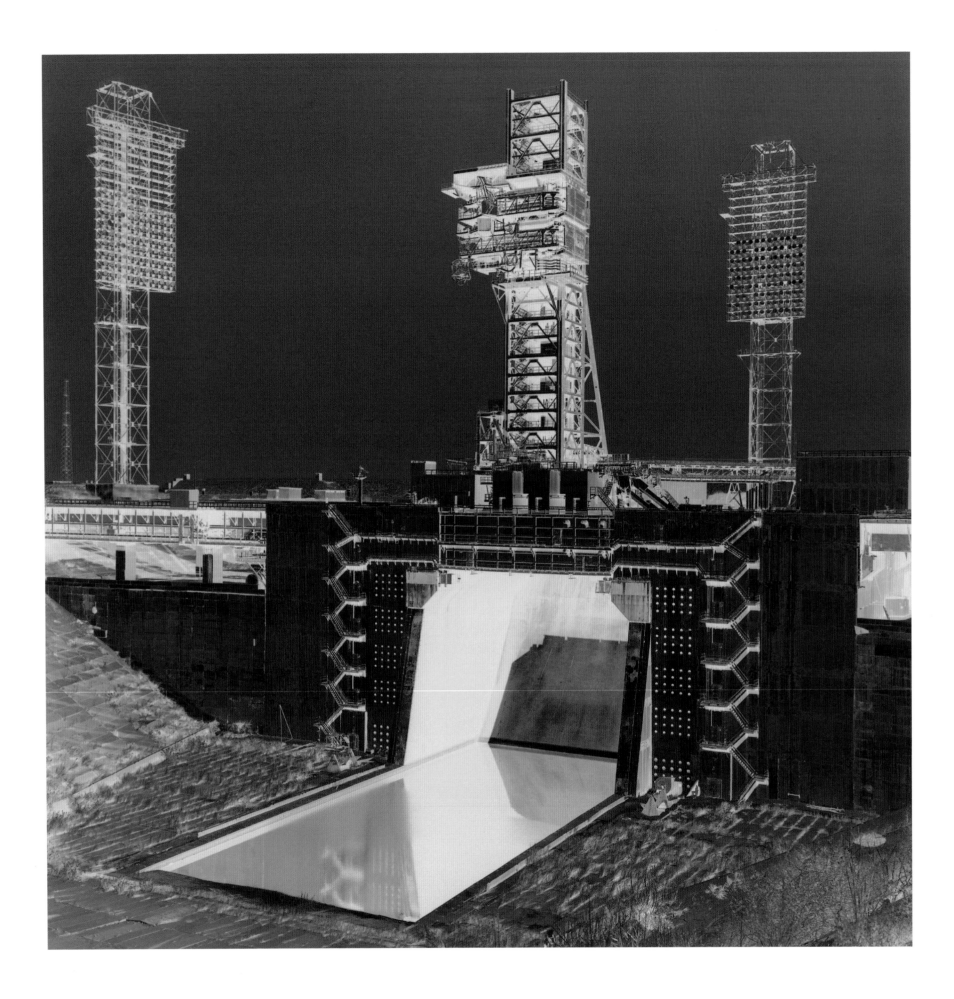

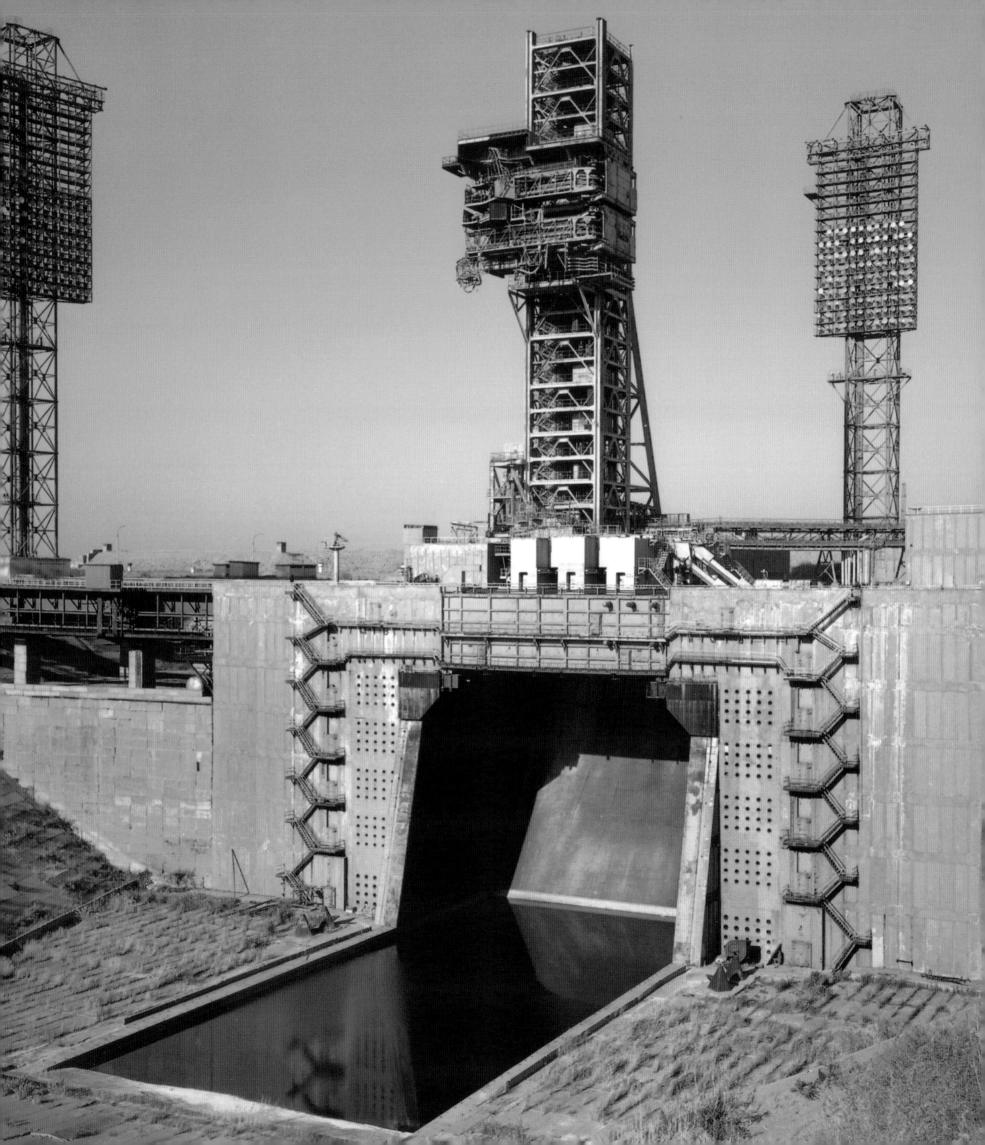

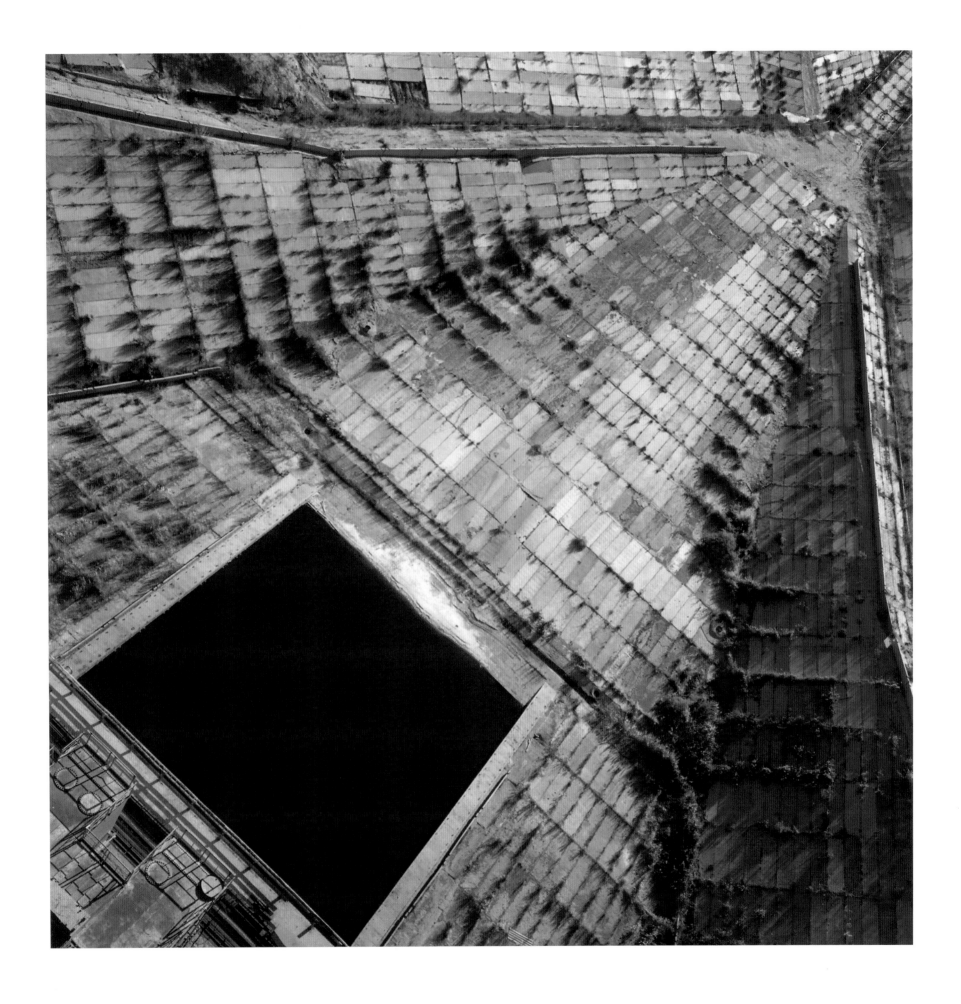

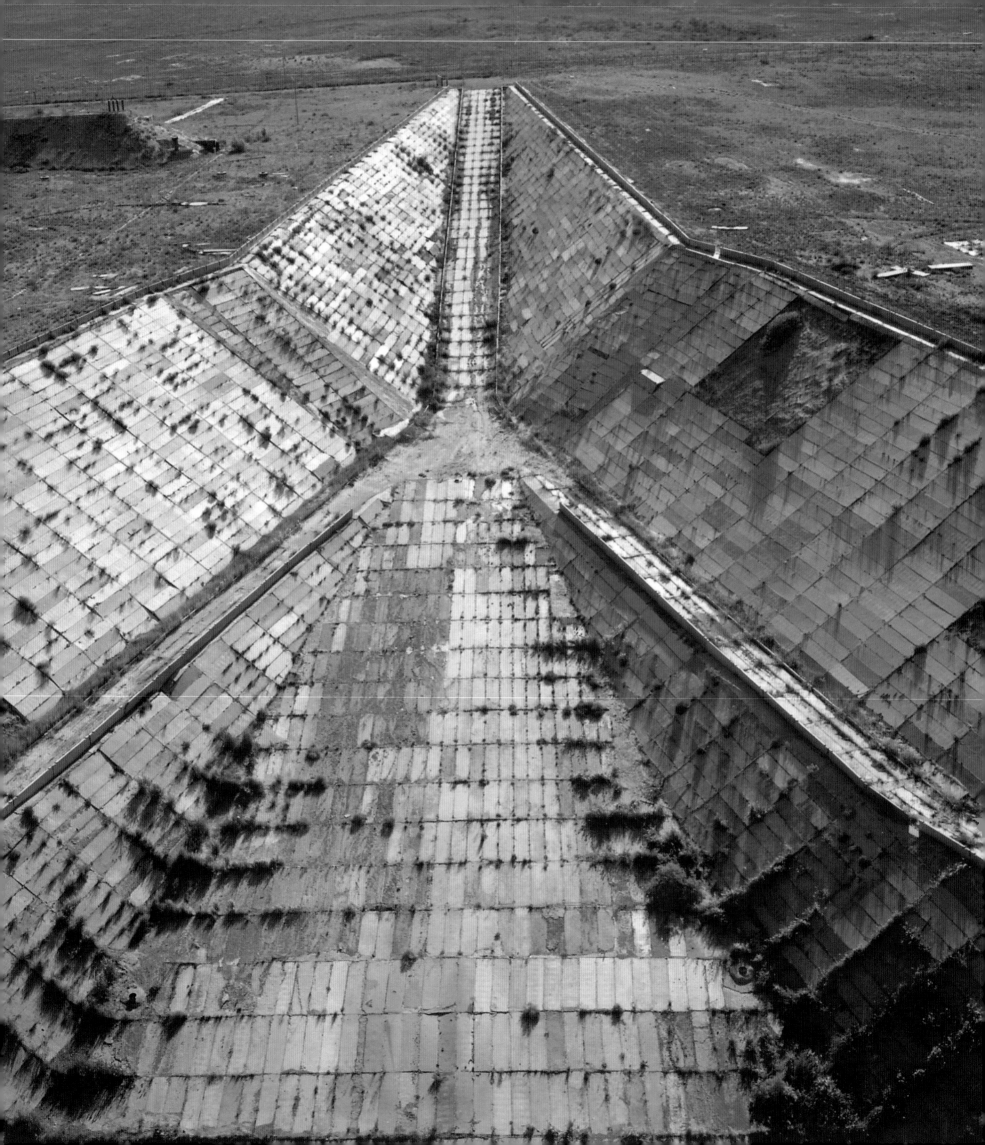

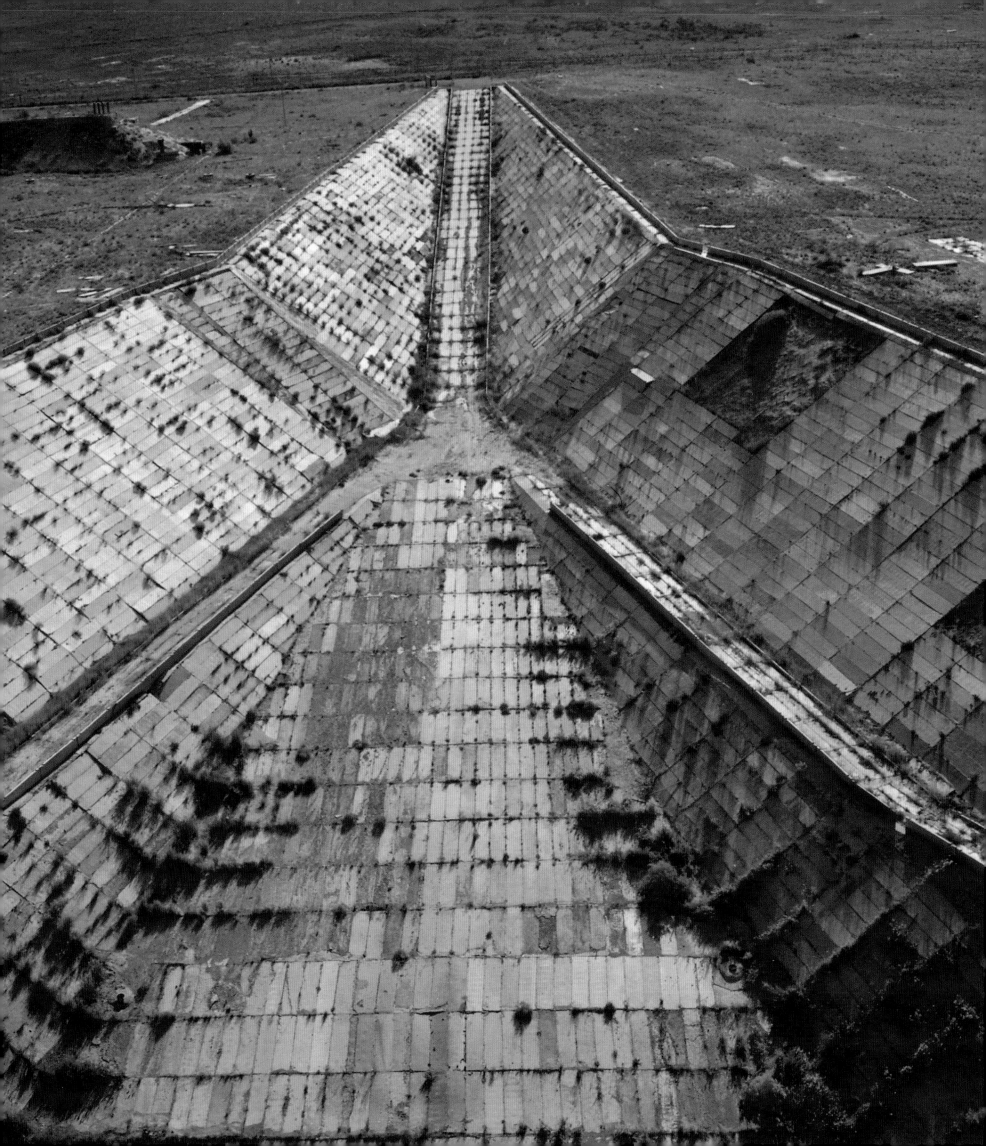

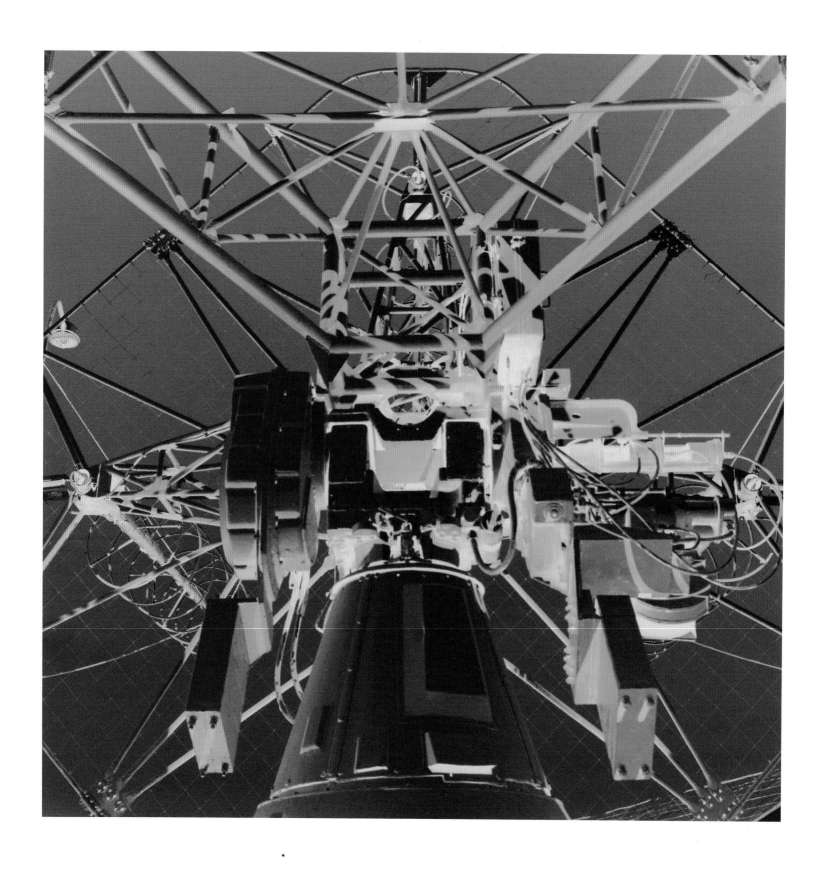

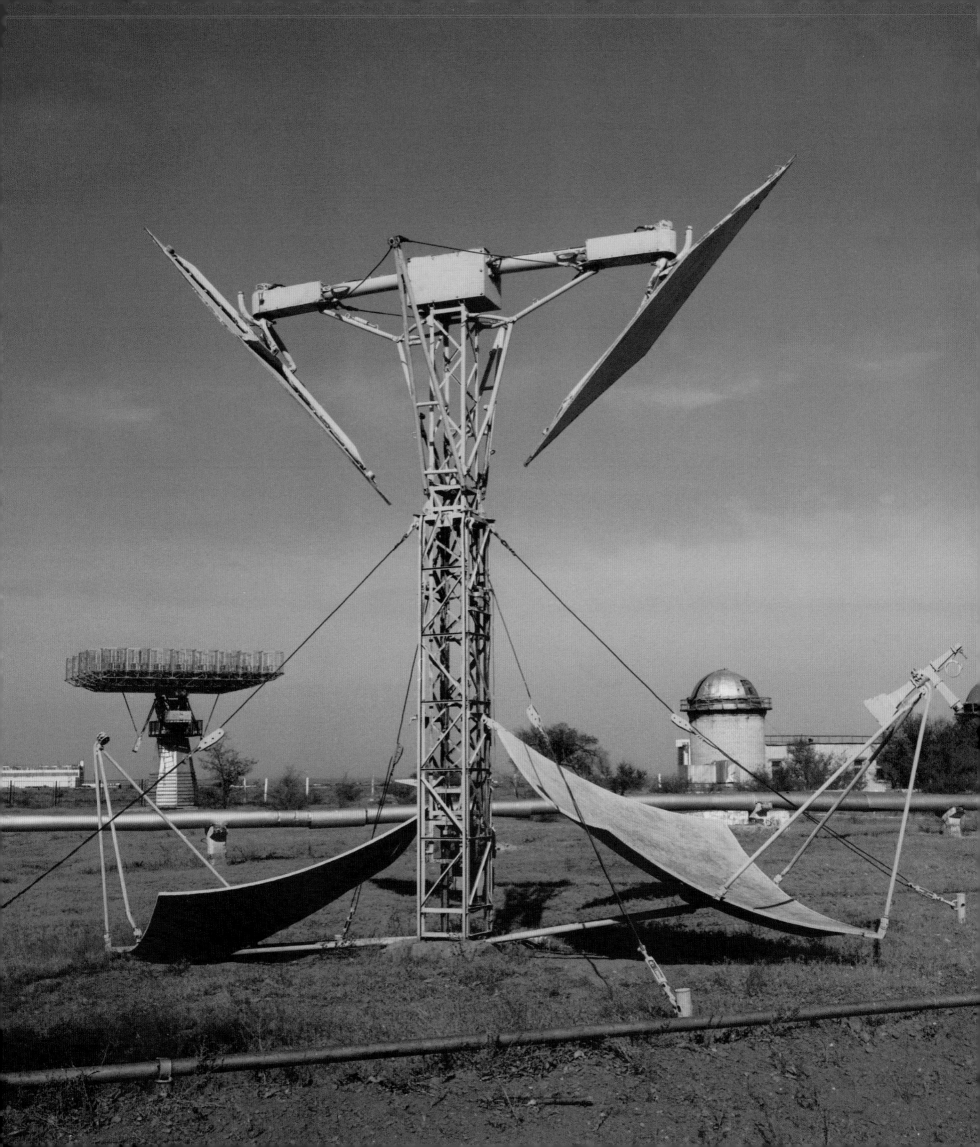

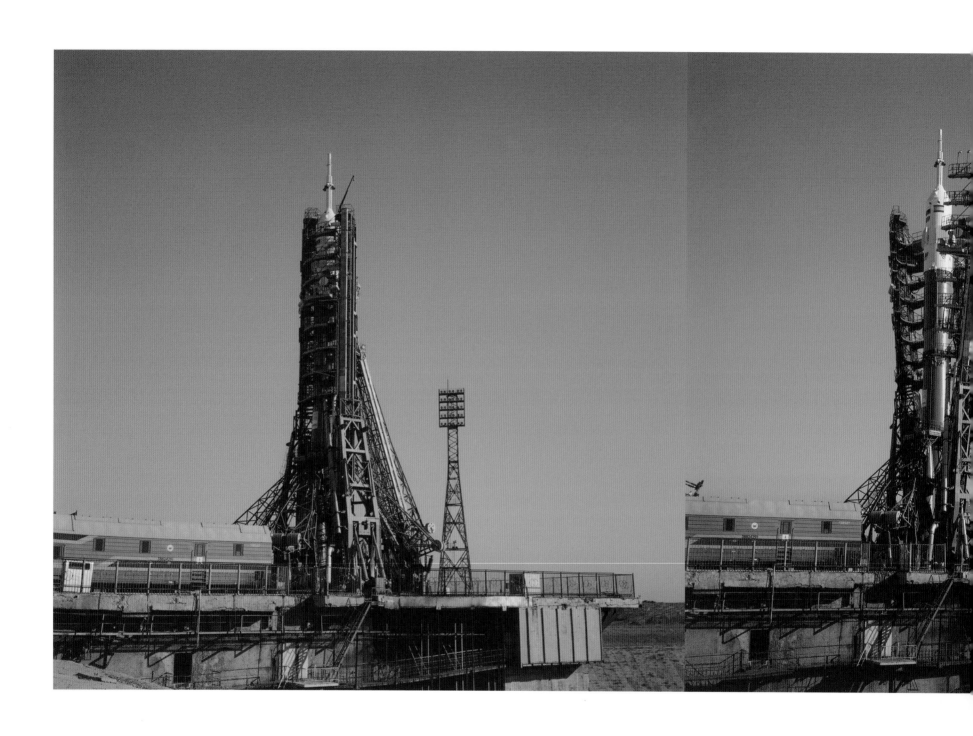

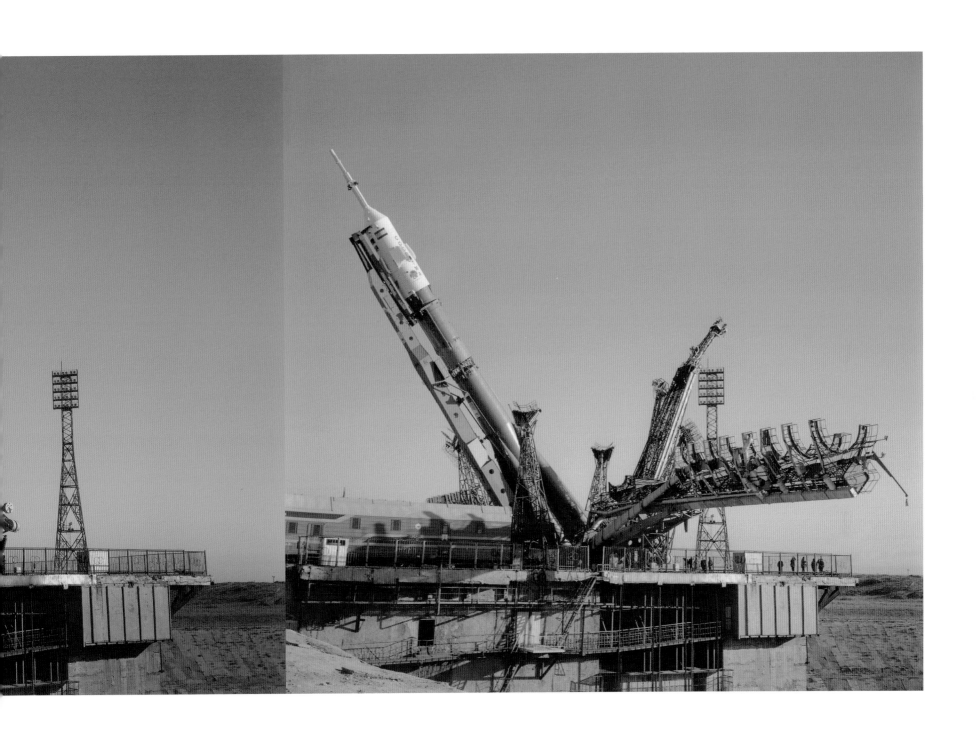

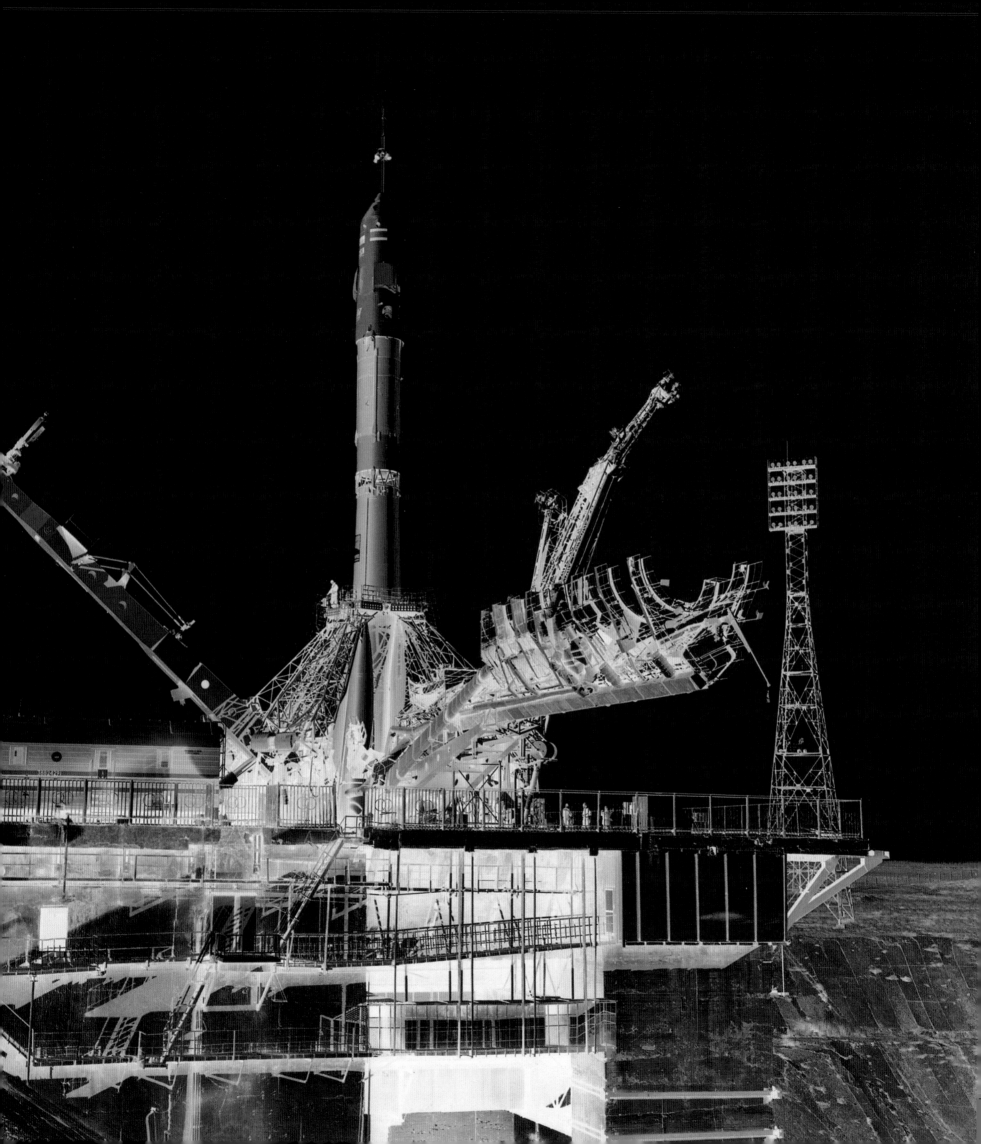

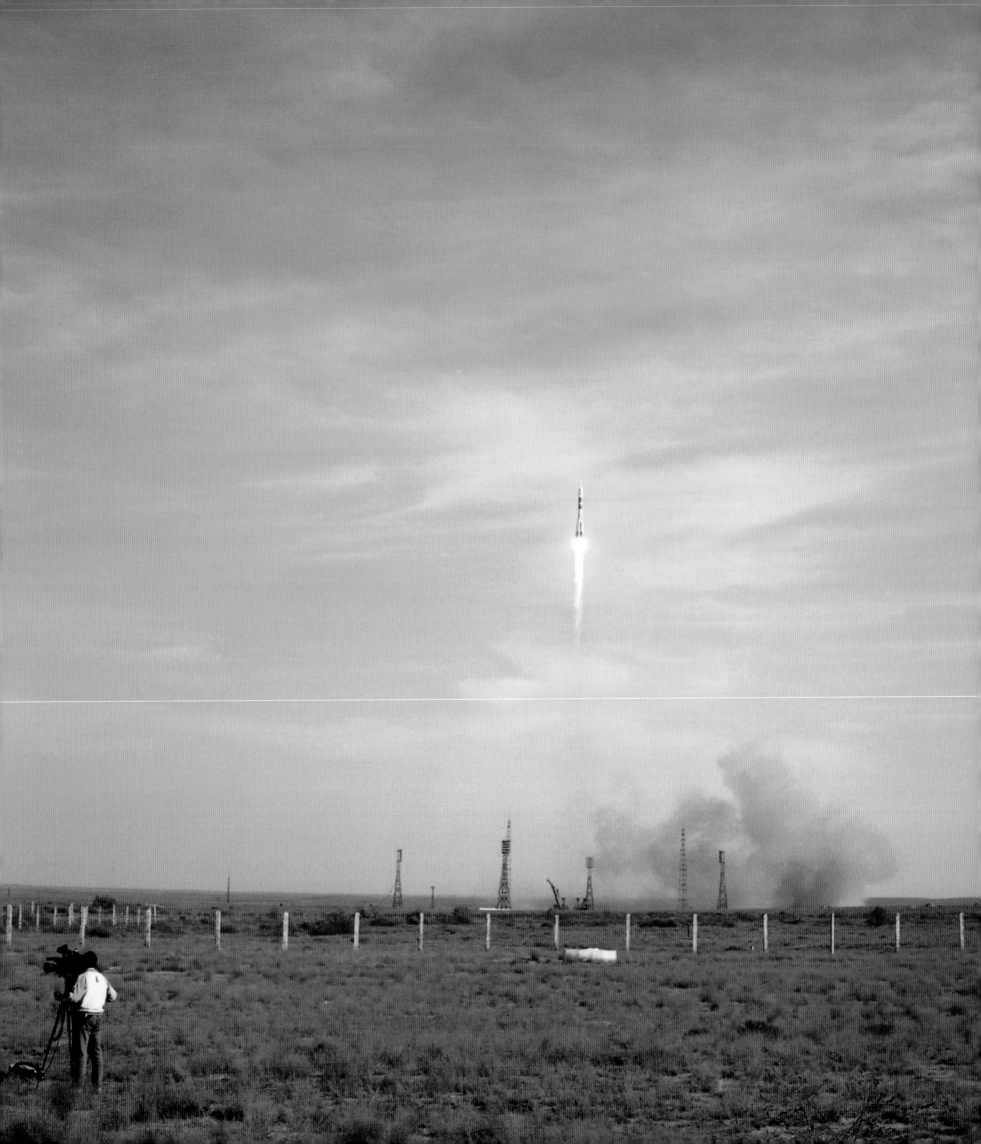

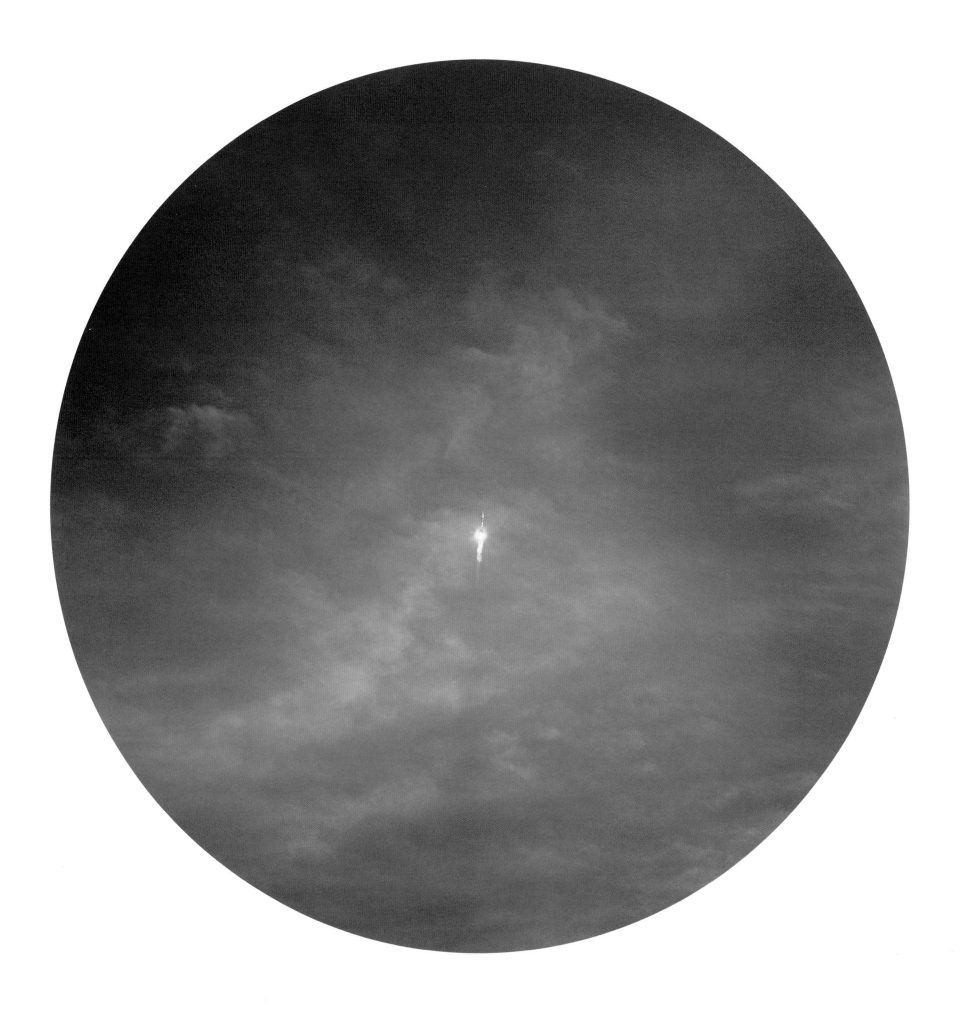

CAPE CANAVERAL AIR FORCE STATION

FLORIDA

PHOTOGRAPHED 2004

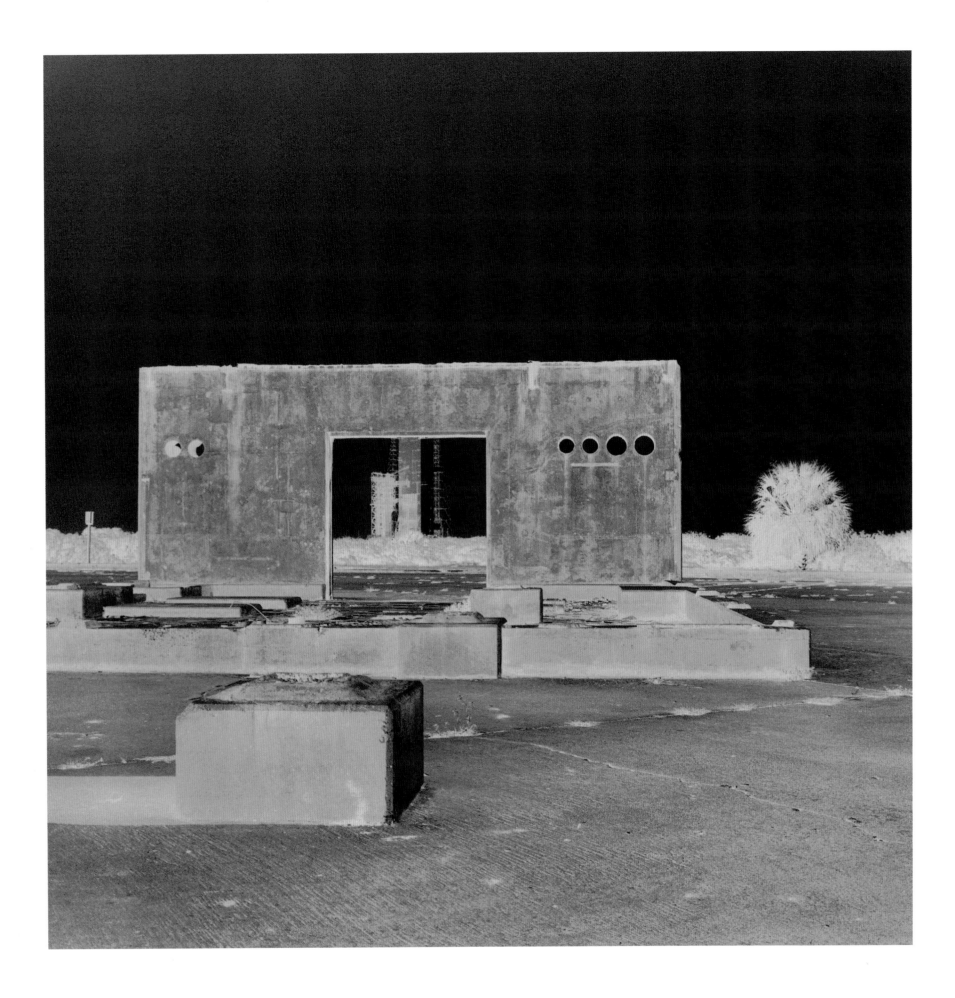

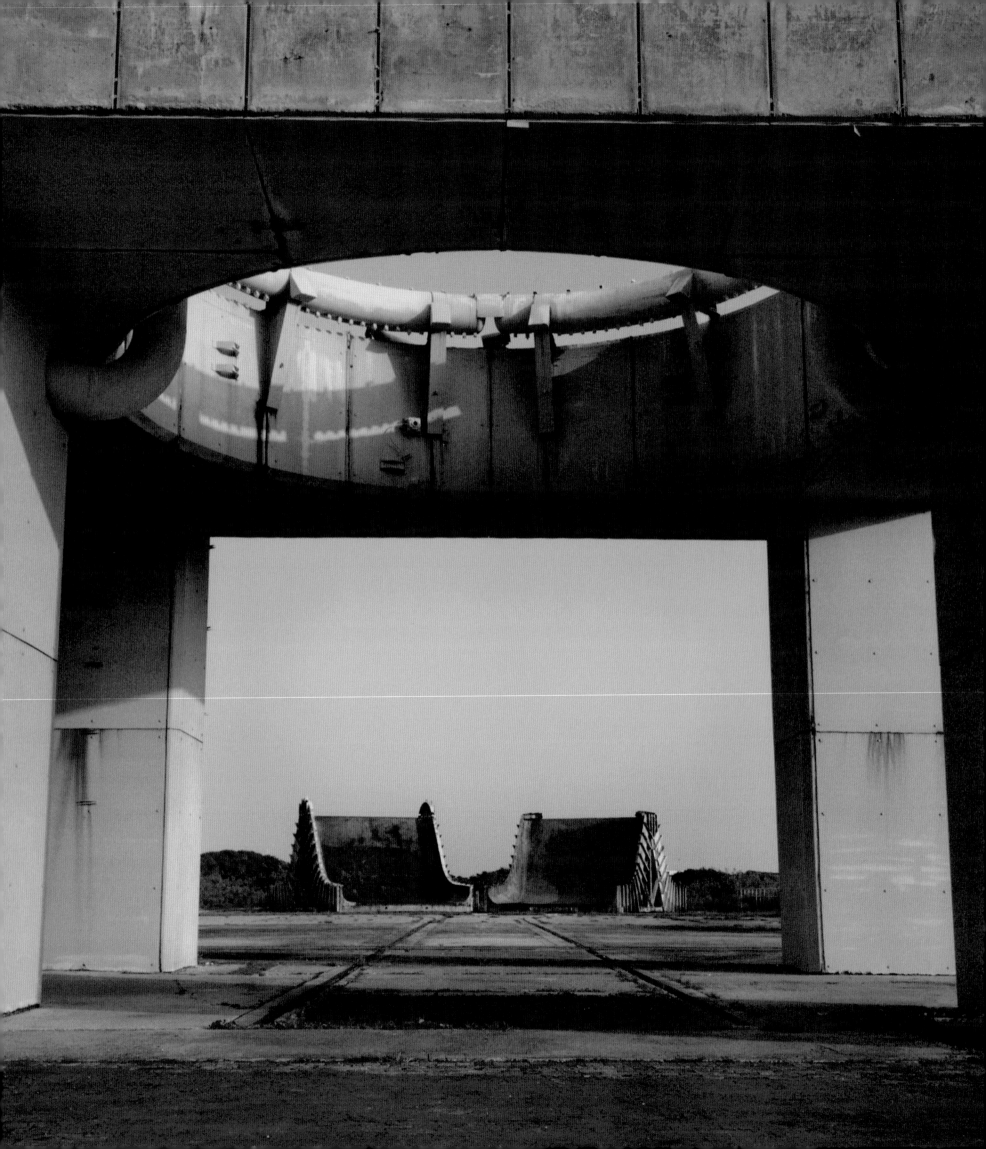

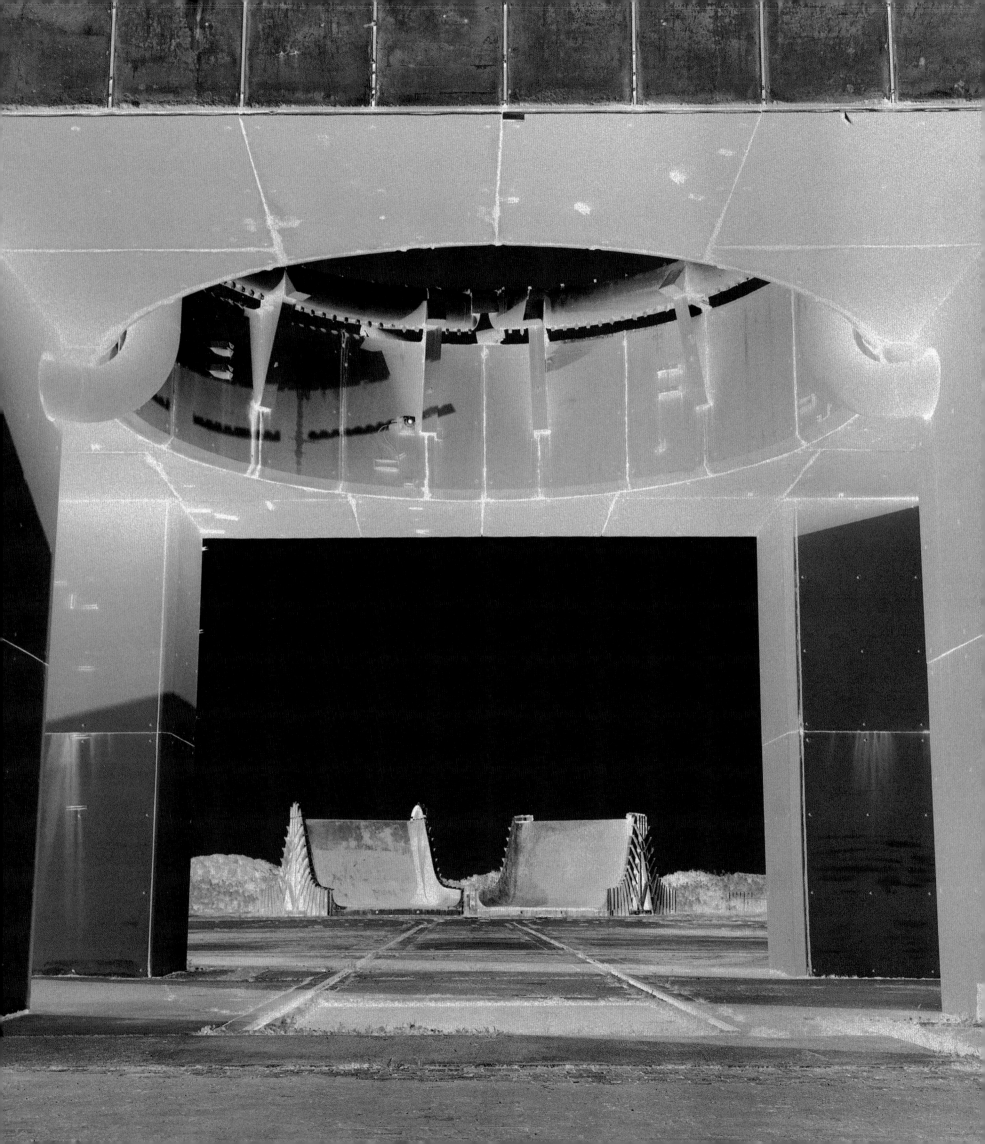

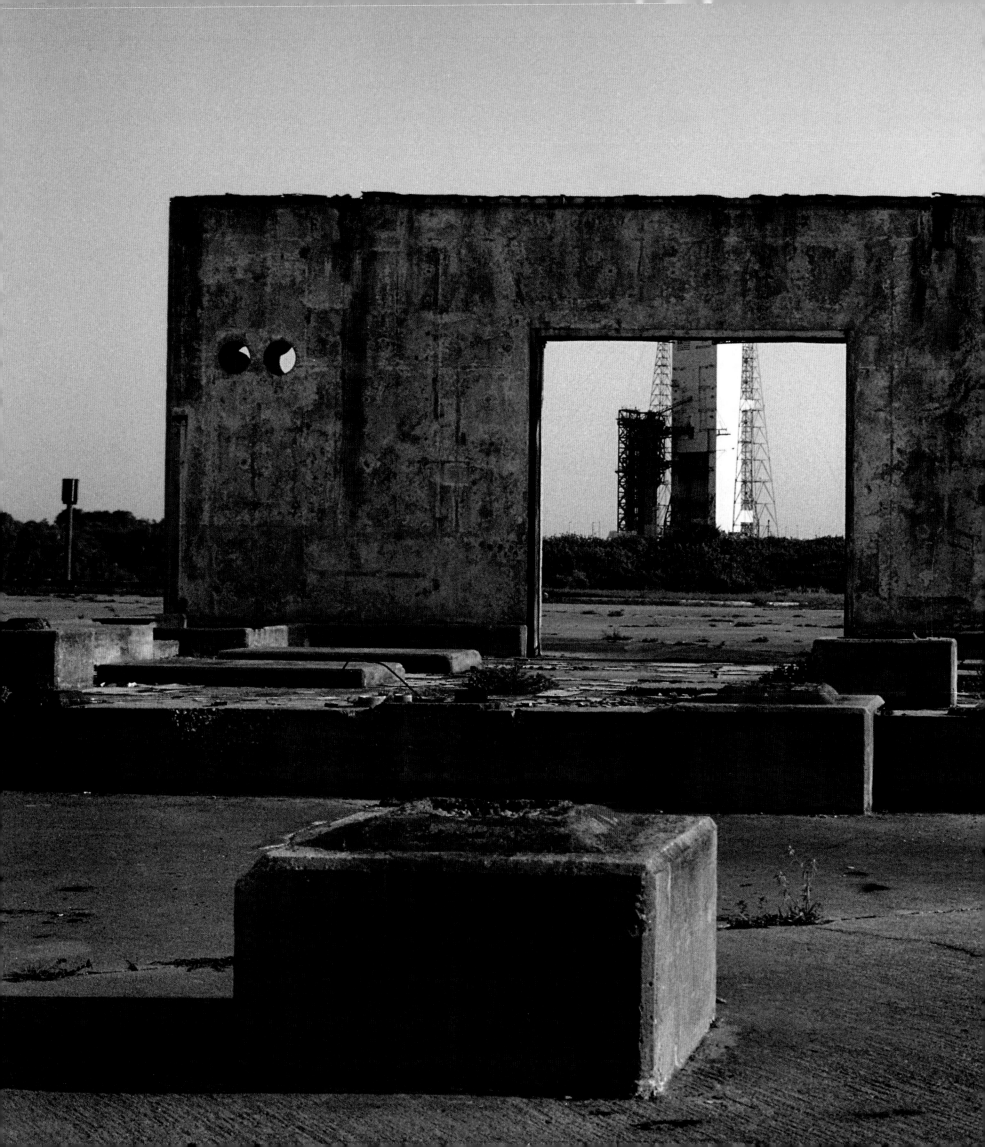

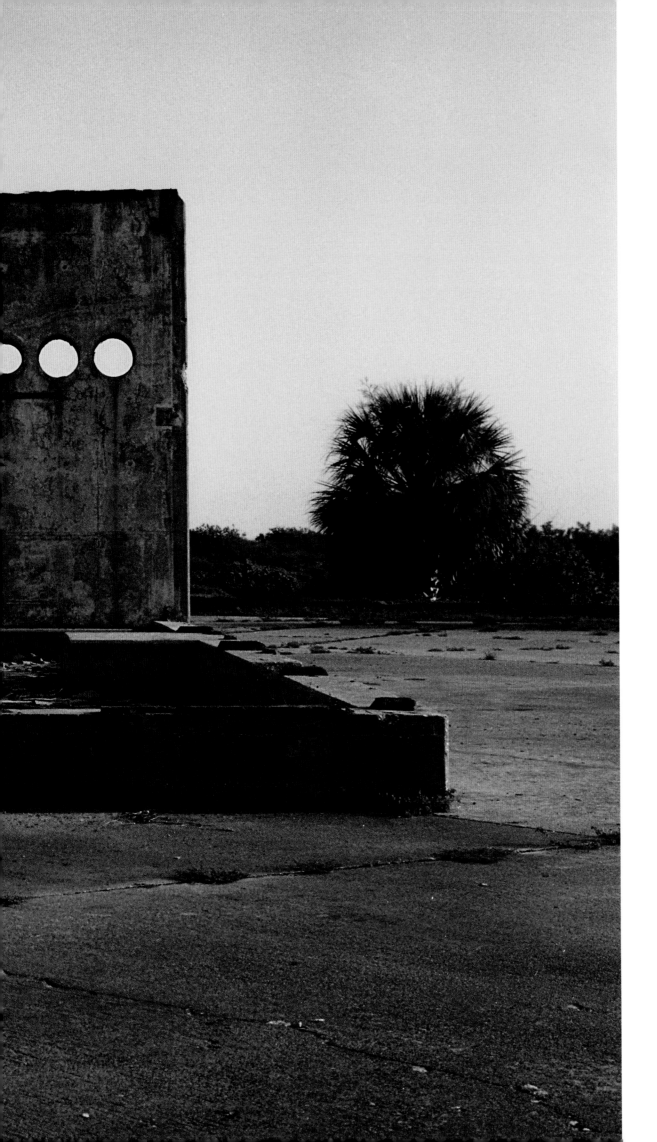

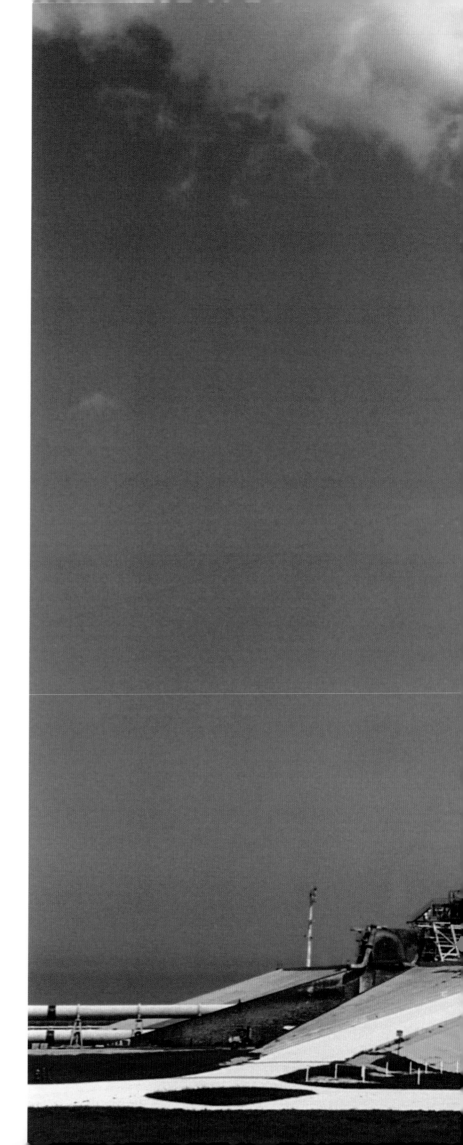

KENNEDY SPACE CENTER

FLORIDA

PHOTOGRAPHED 2004

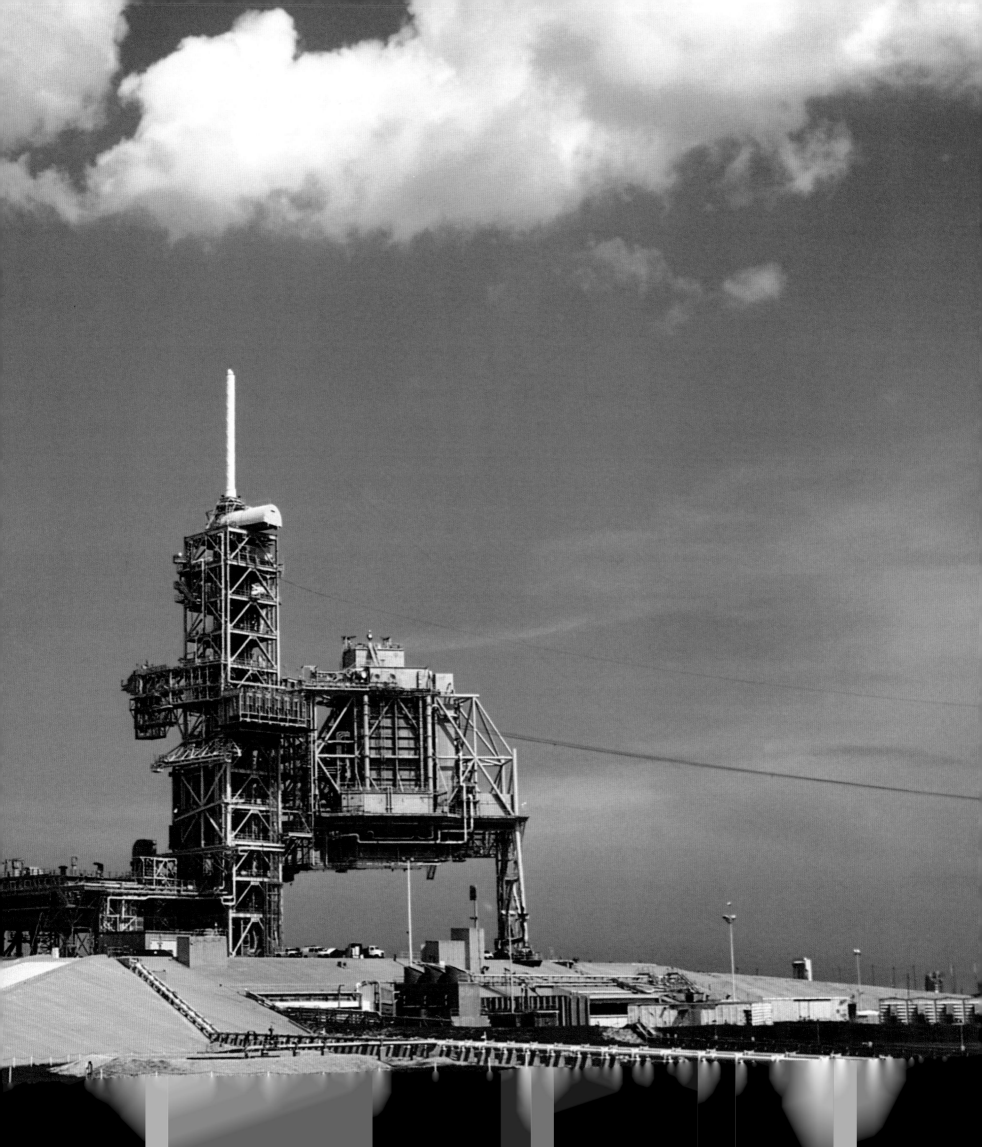

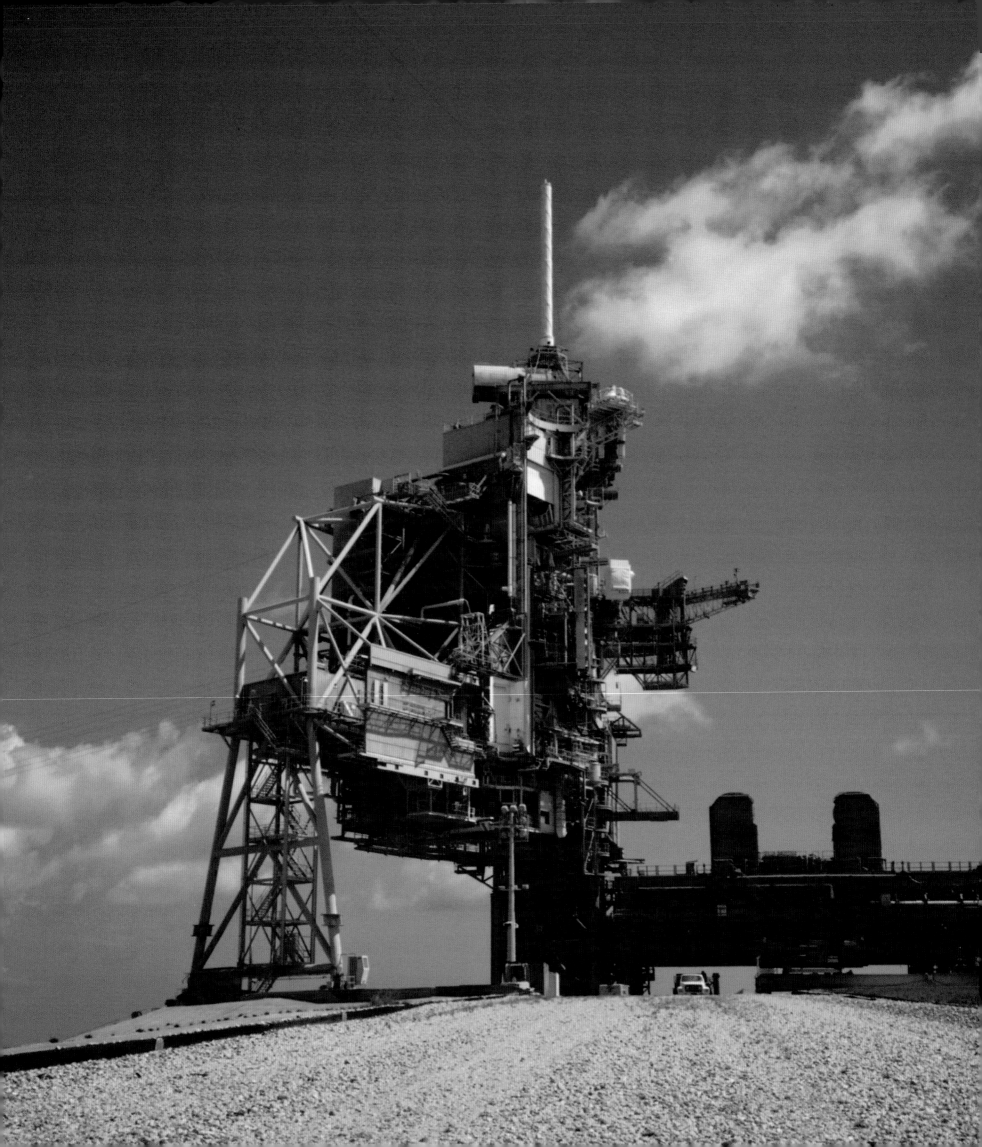

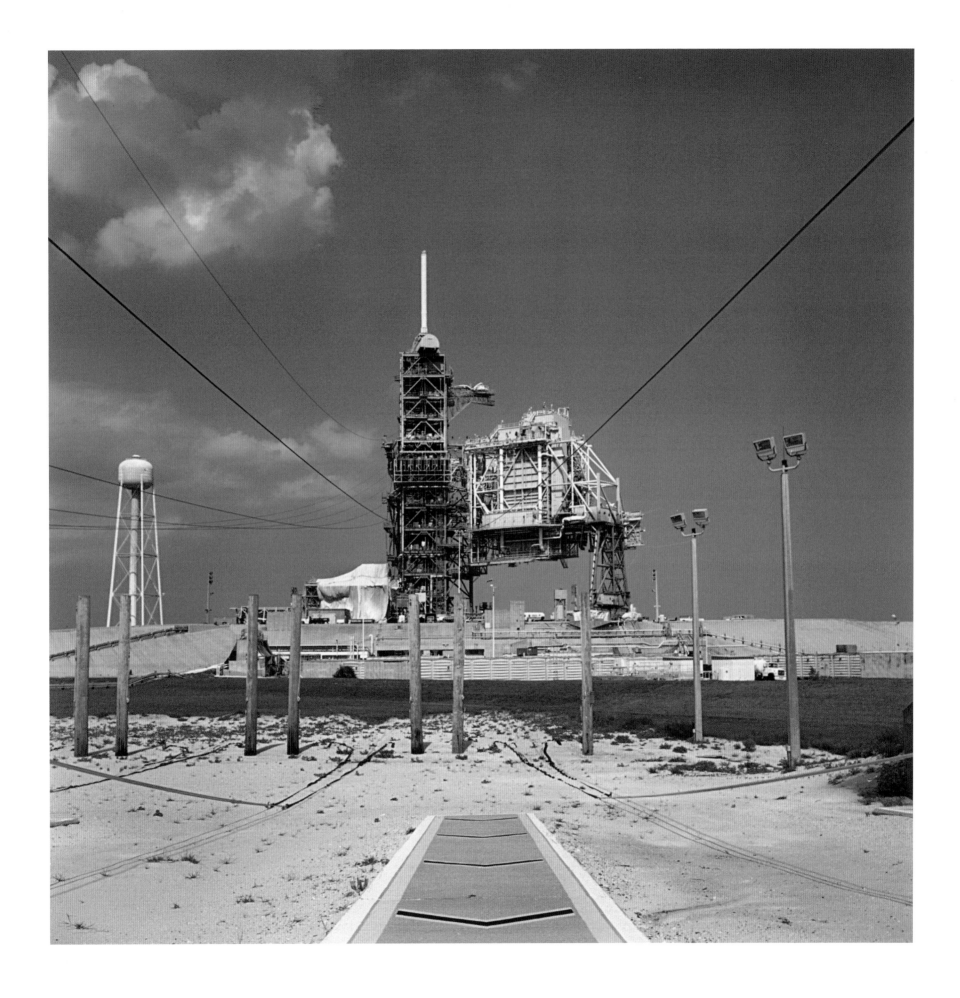

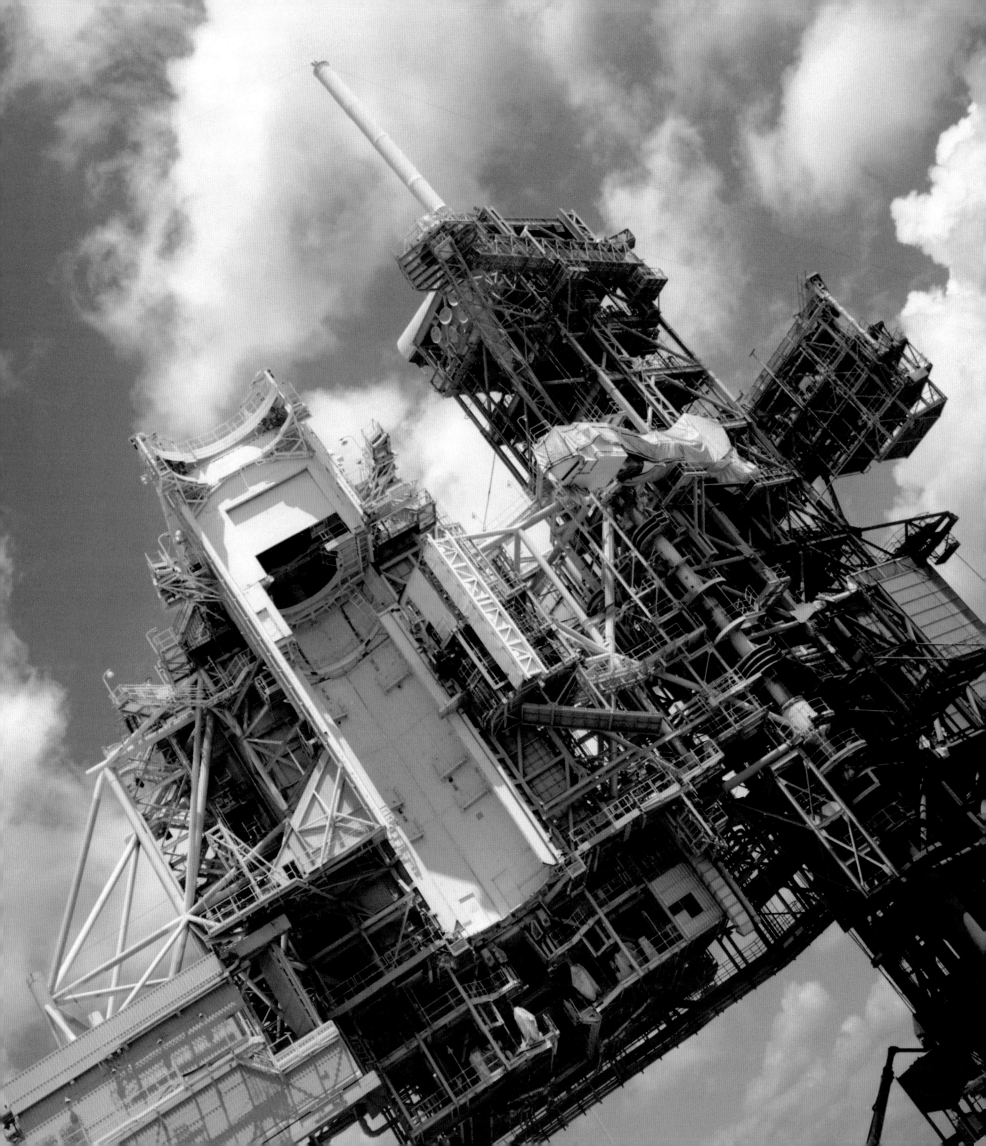

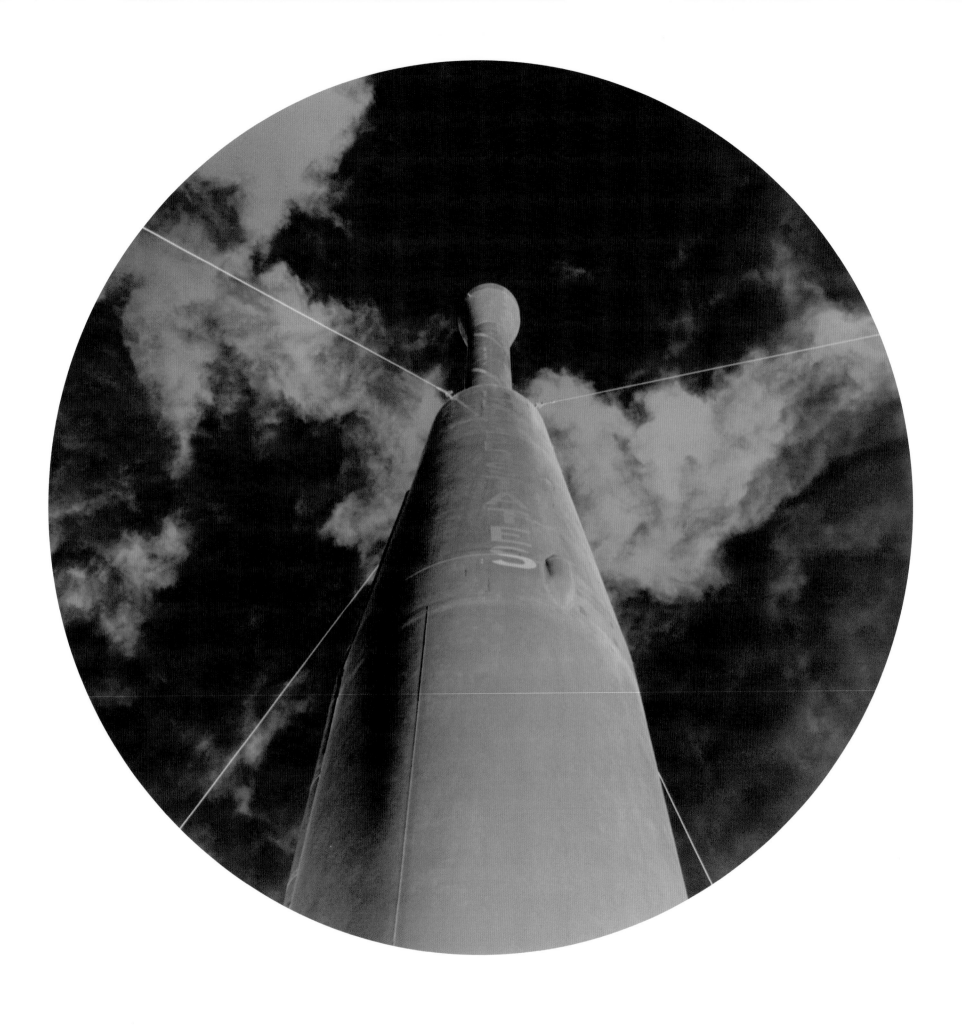

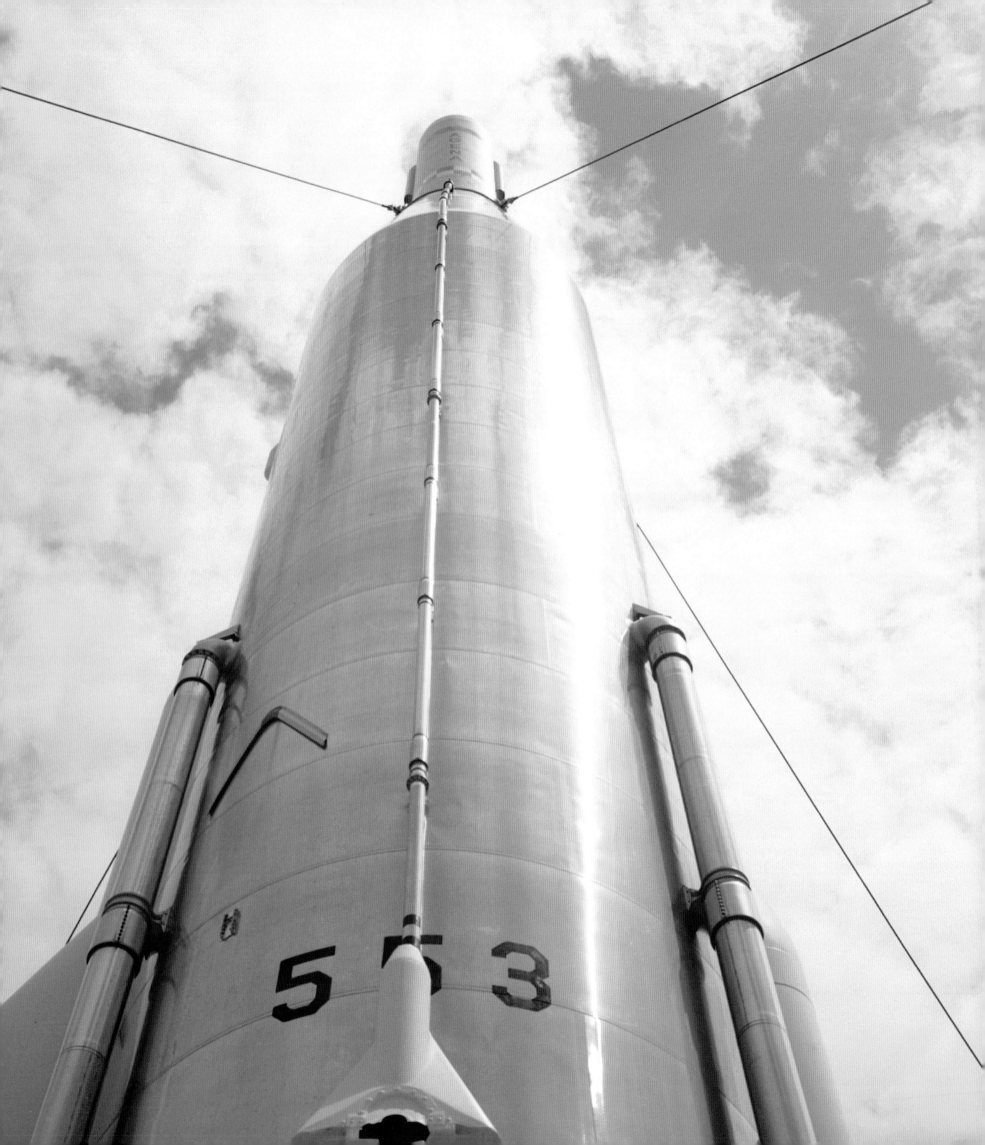

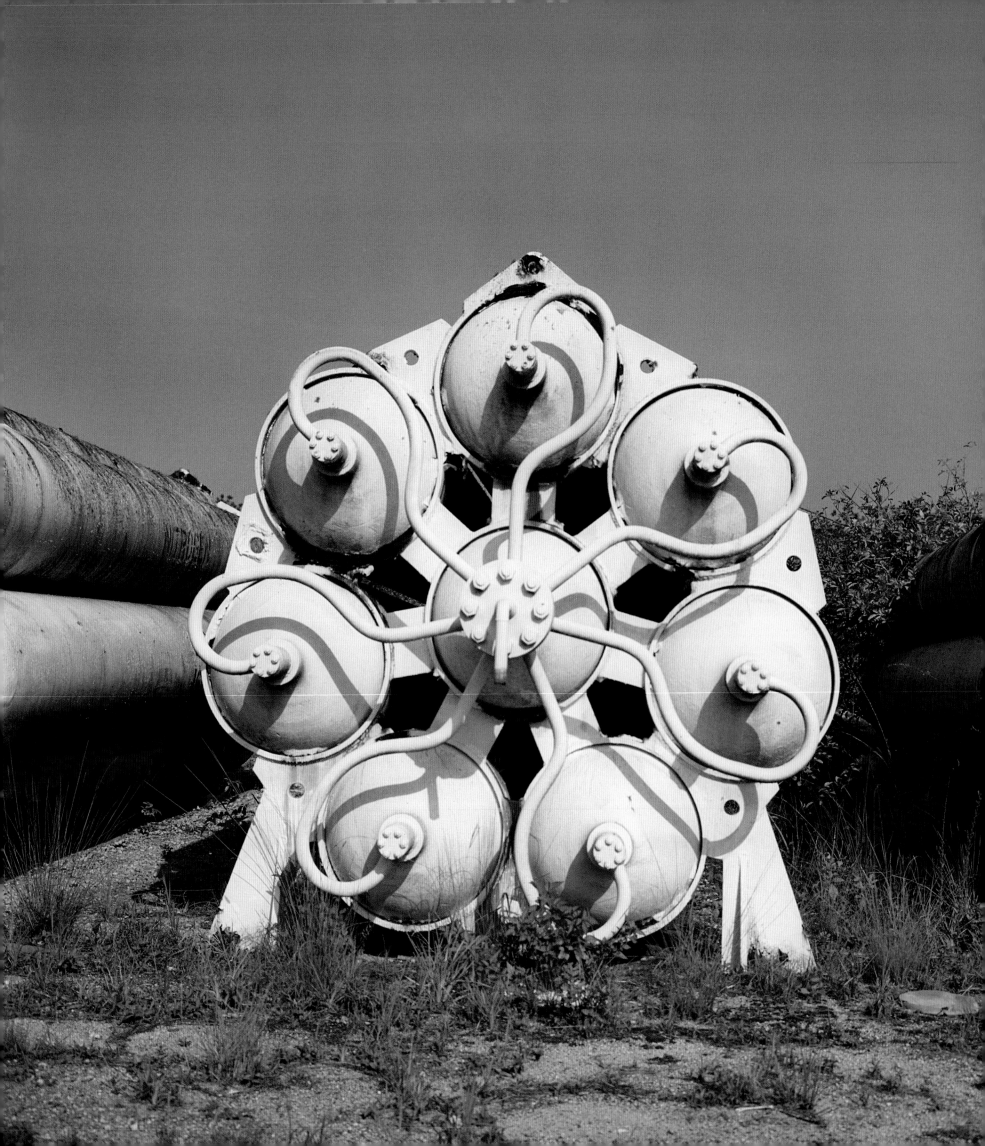

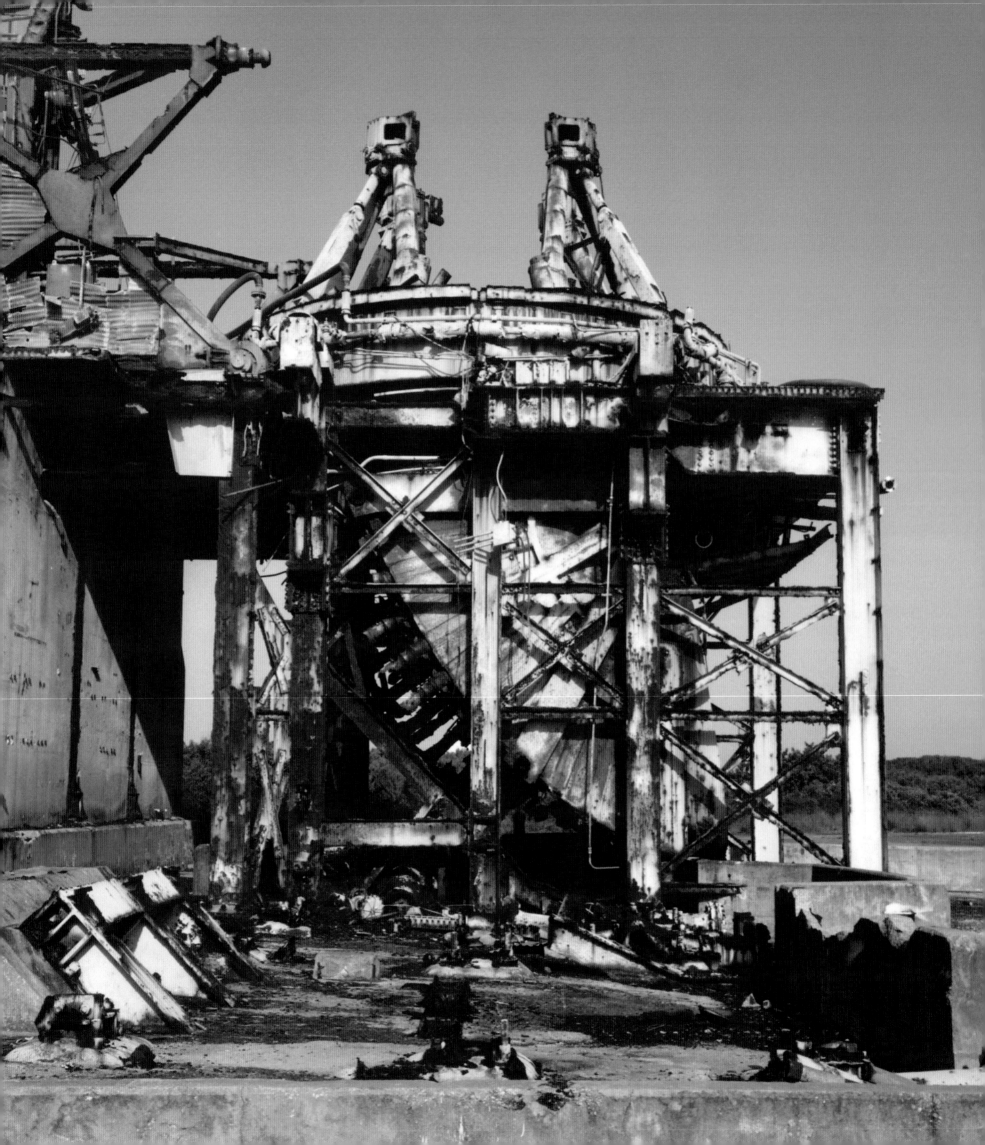

EDWARDS AIR FORCE BASE

CALIFORNIA

PHOTOGRAPHED 2004

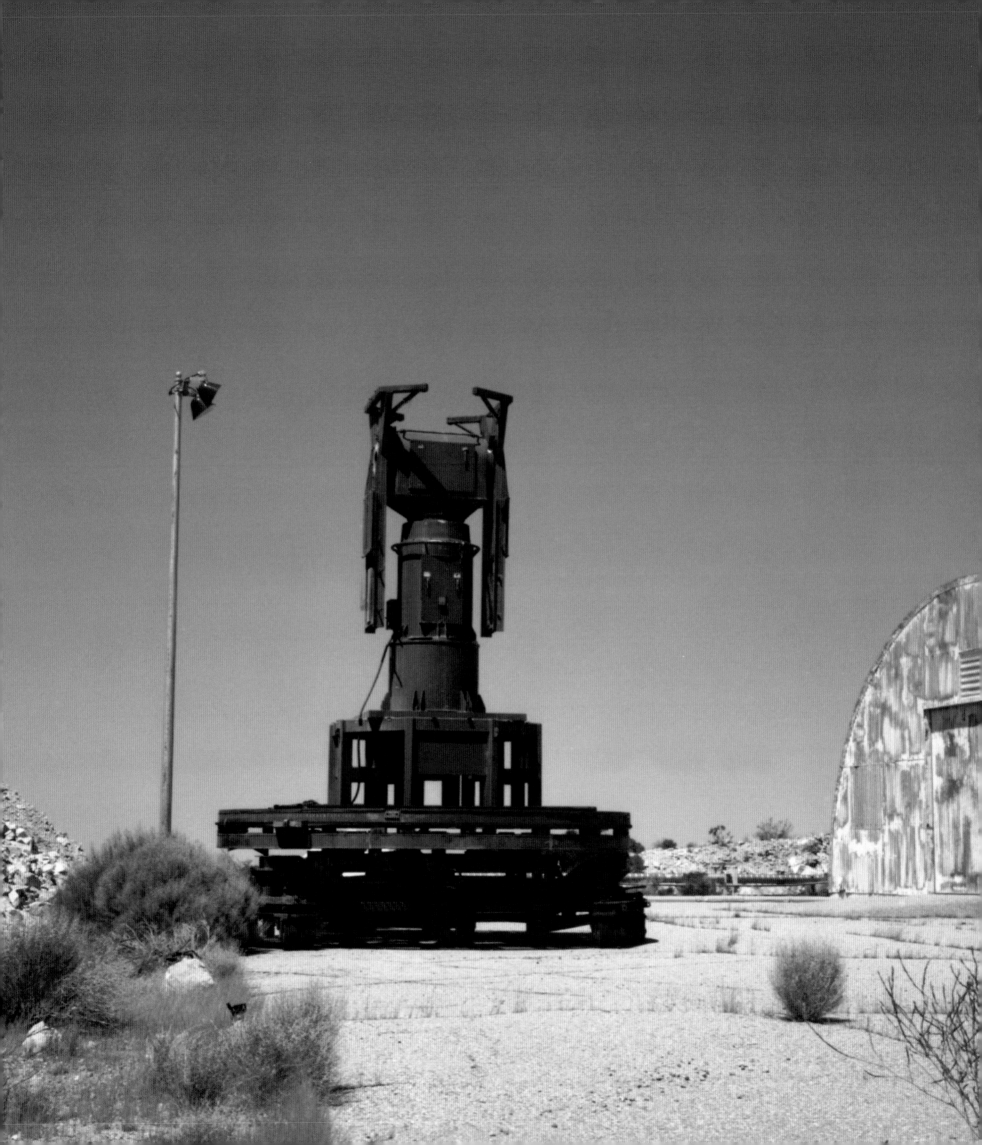

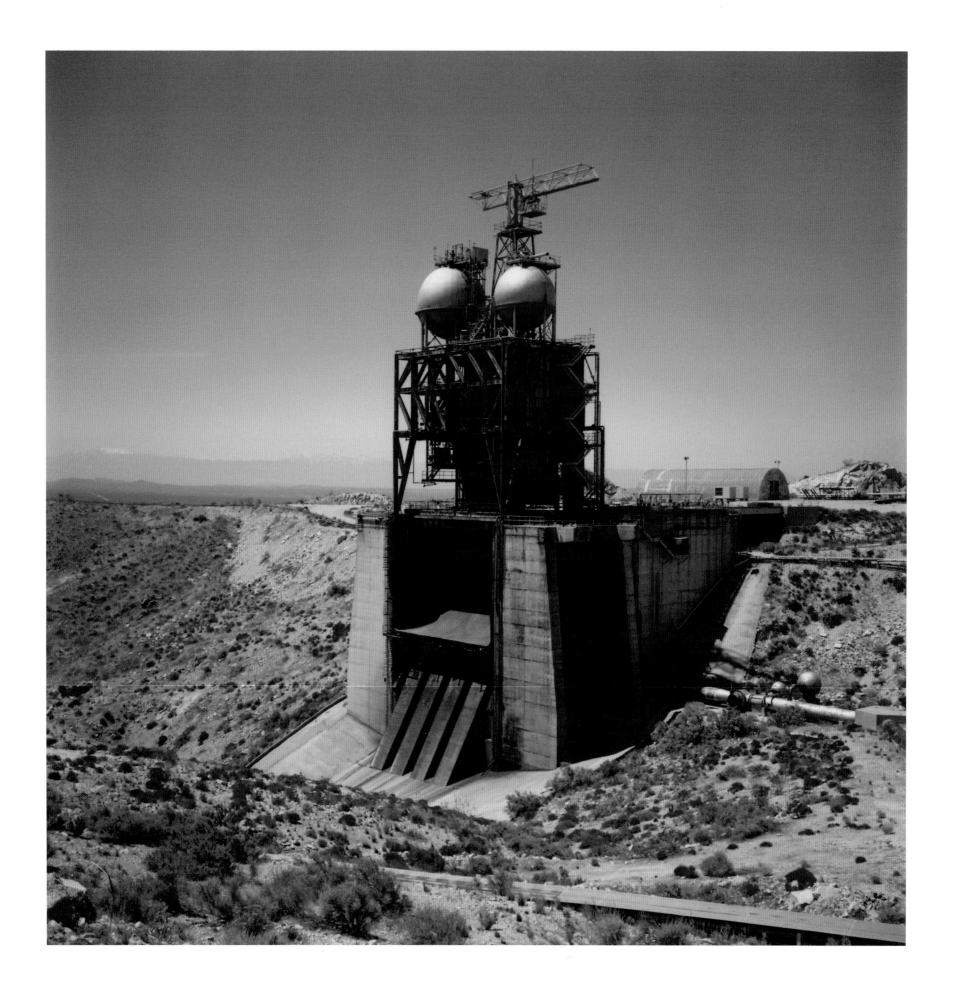

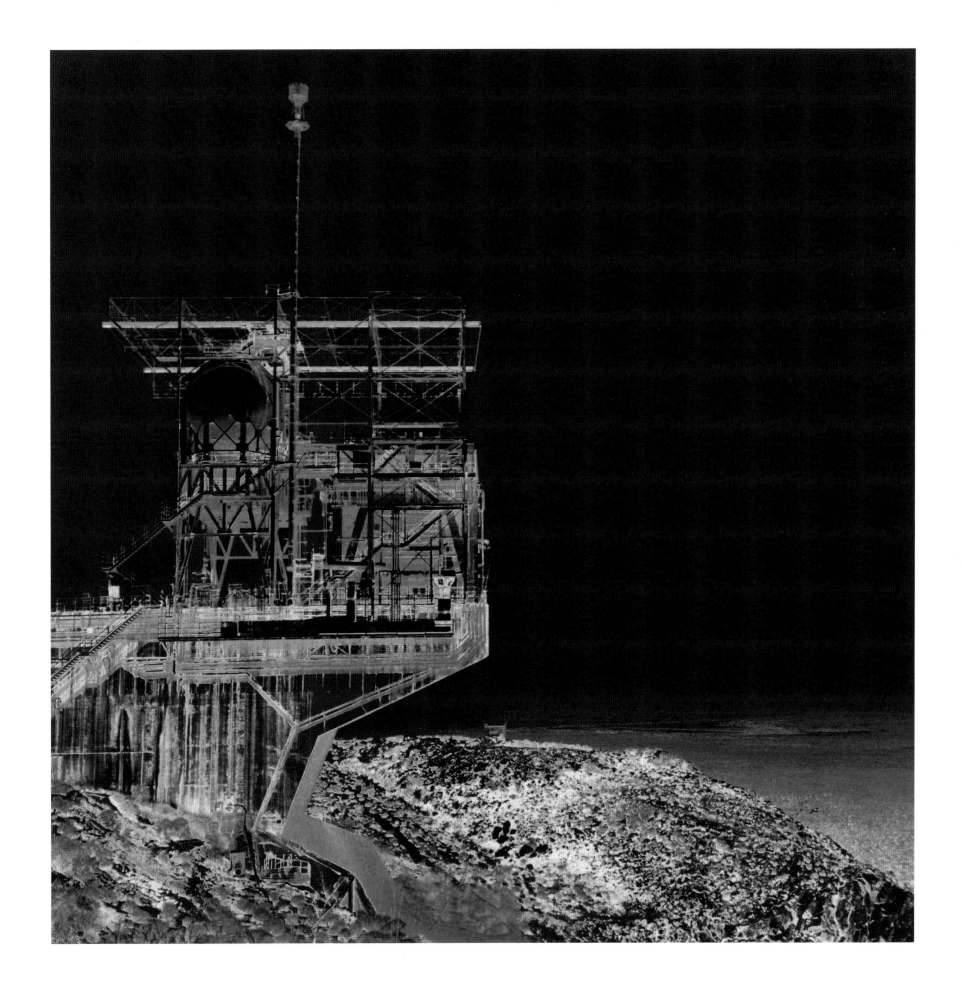

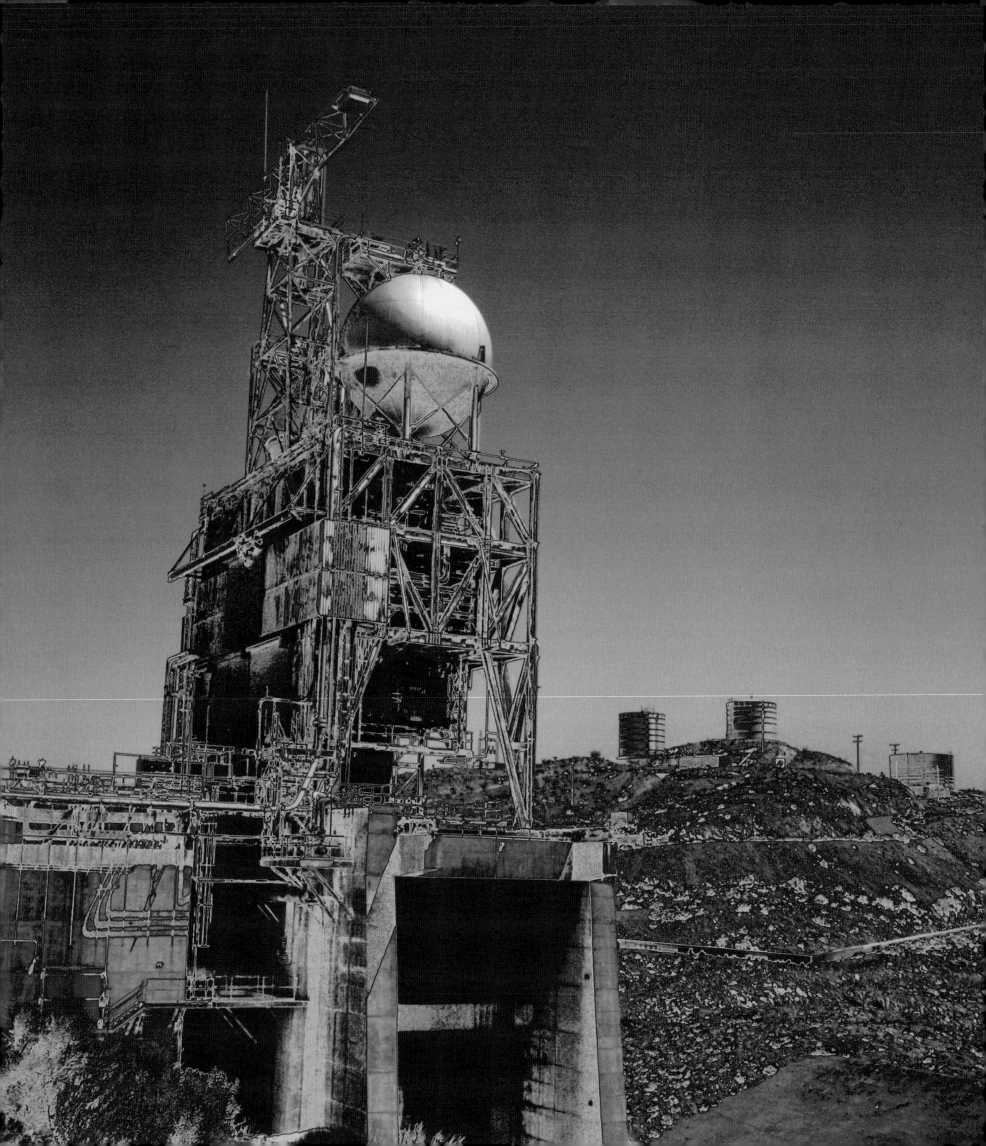

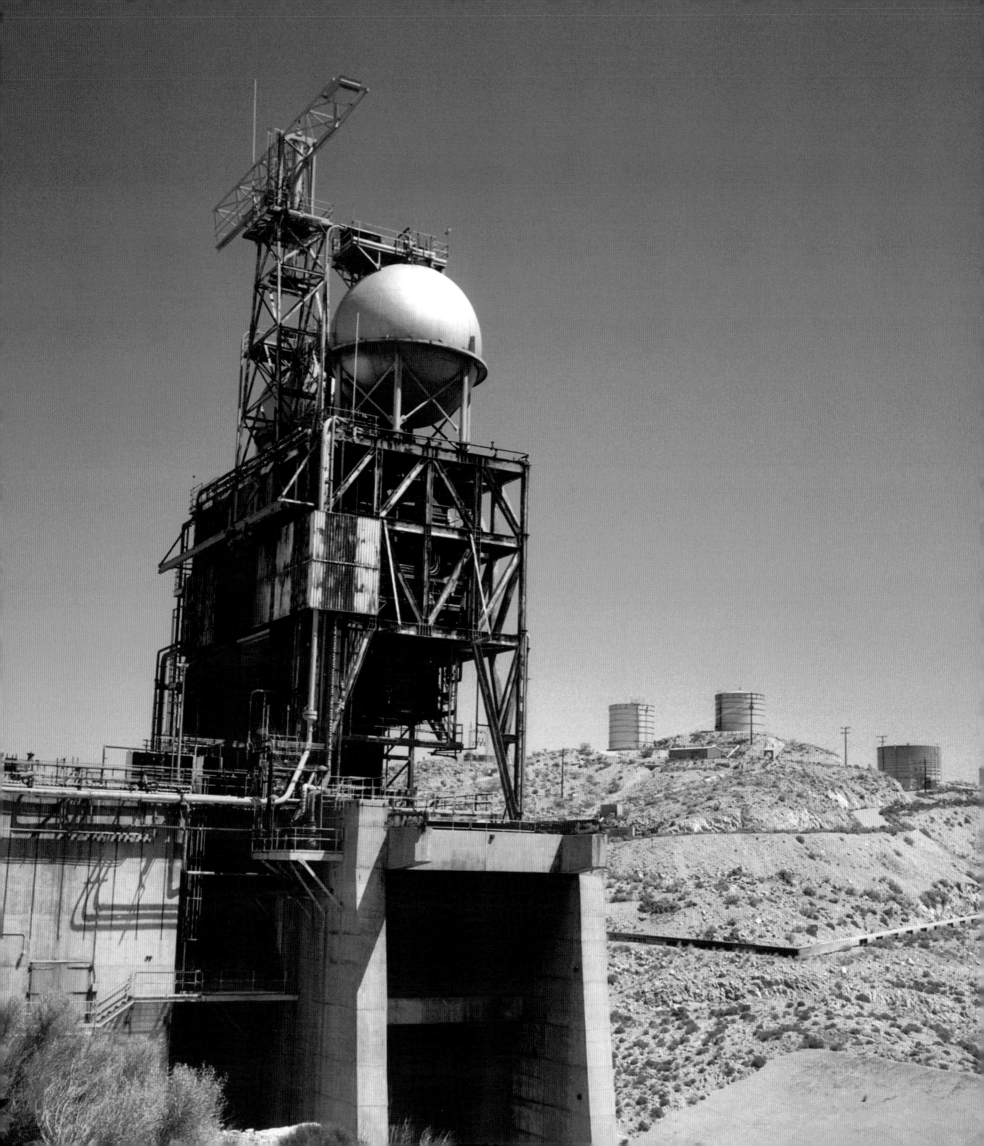

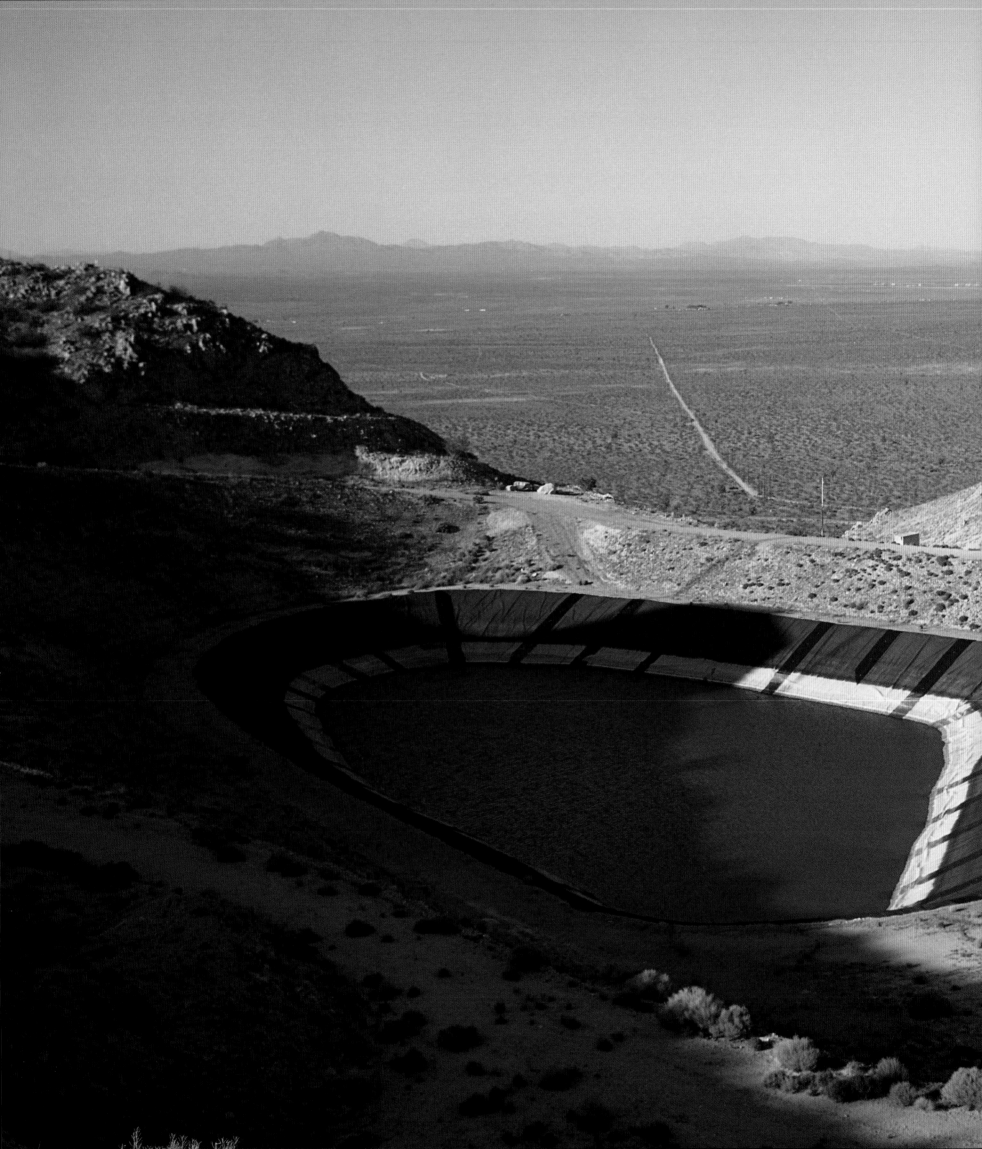

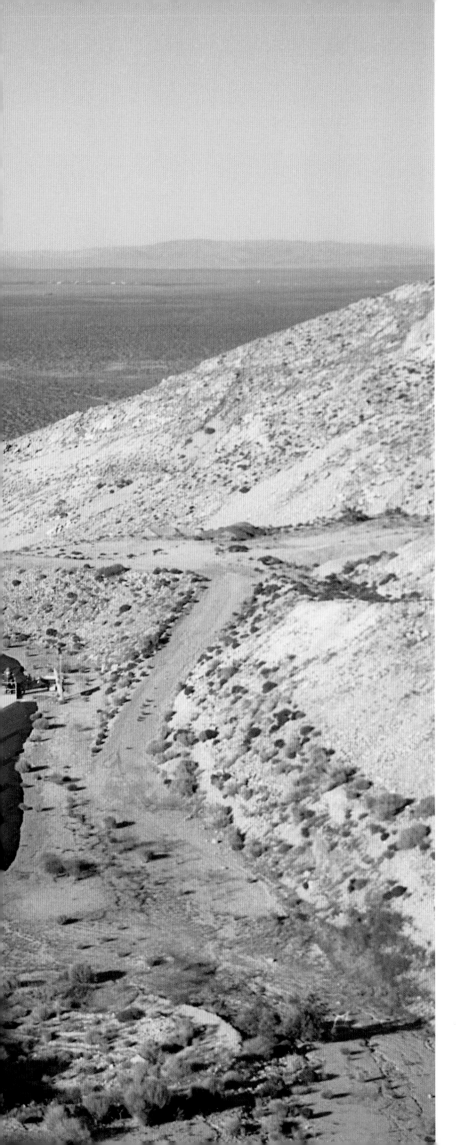

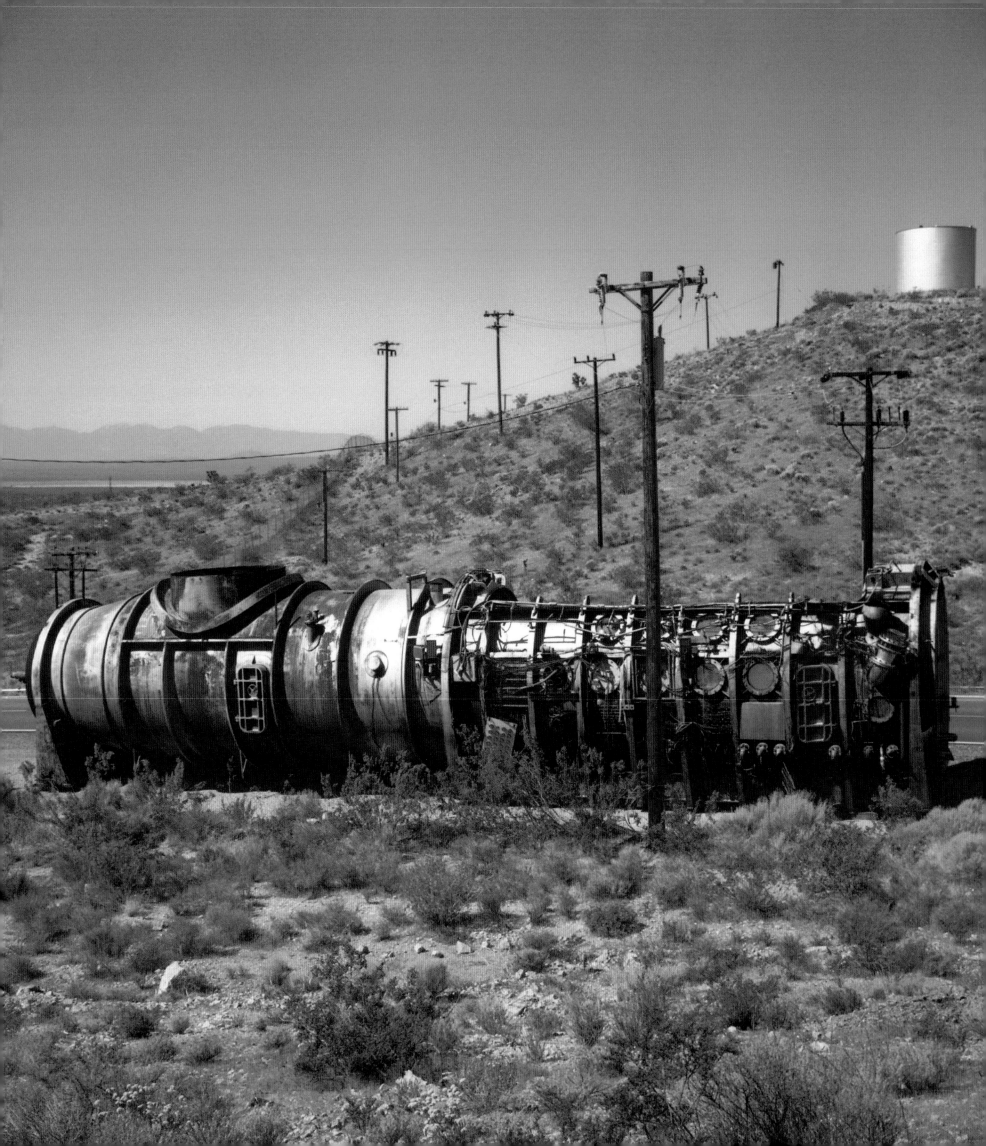

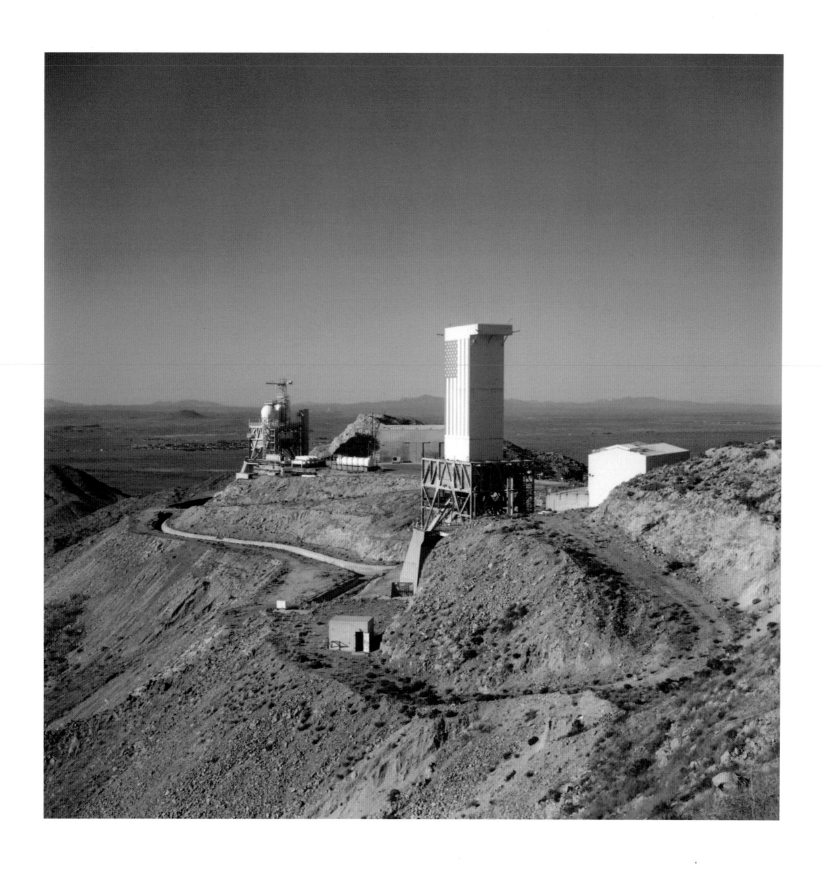

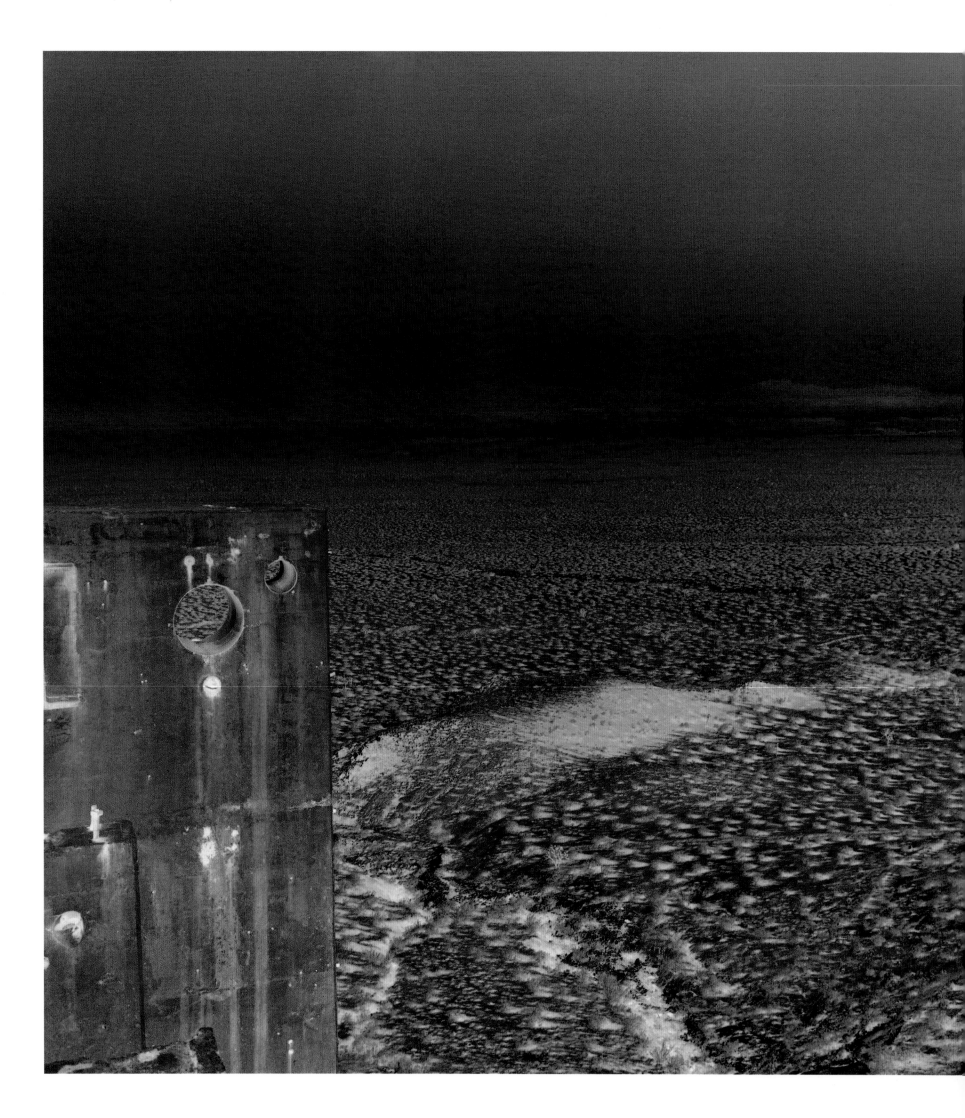

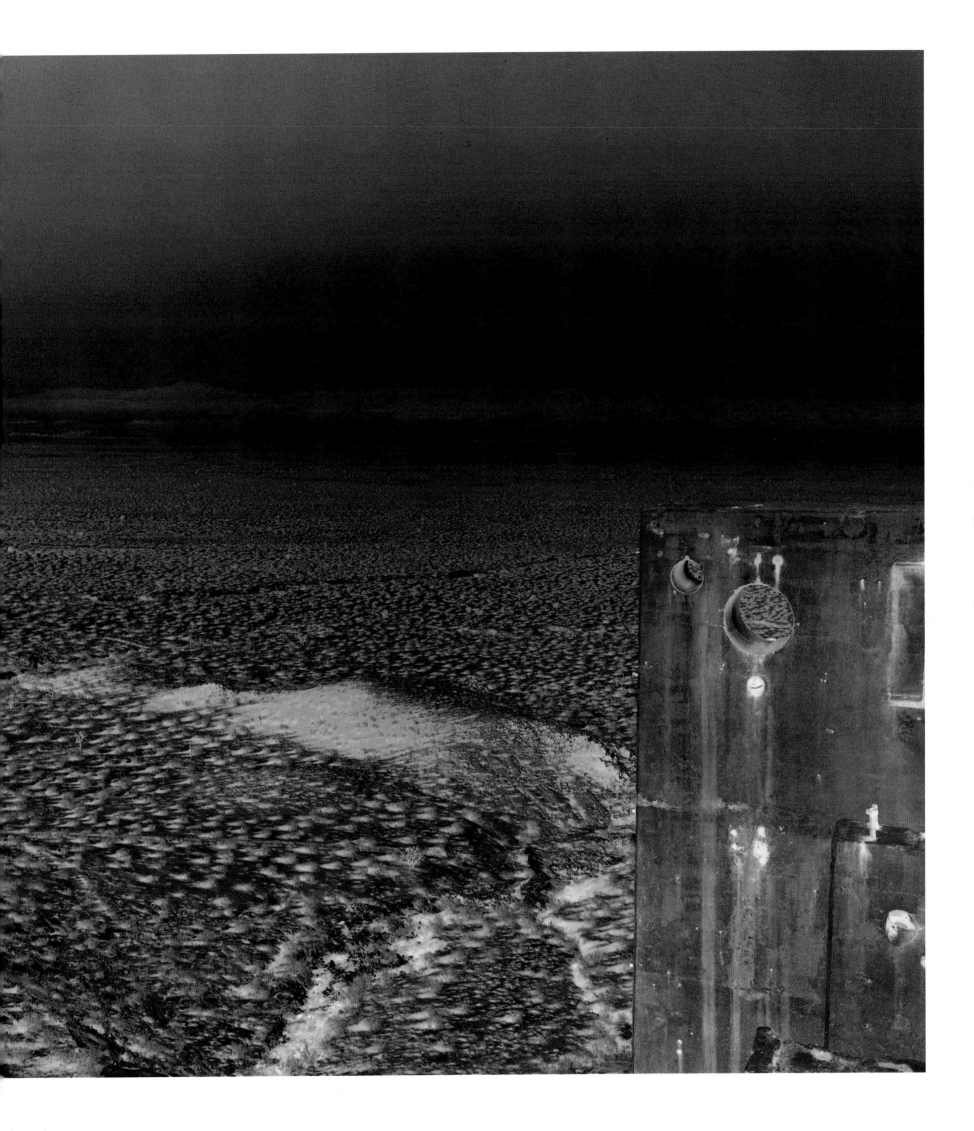

VANDENBERG
AIR FORCE
BASE

CALIFORNIA

PHOTOGRAPHED 2005

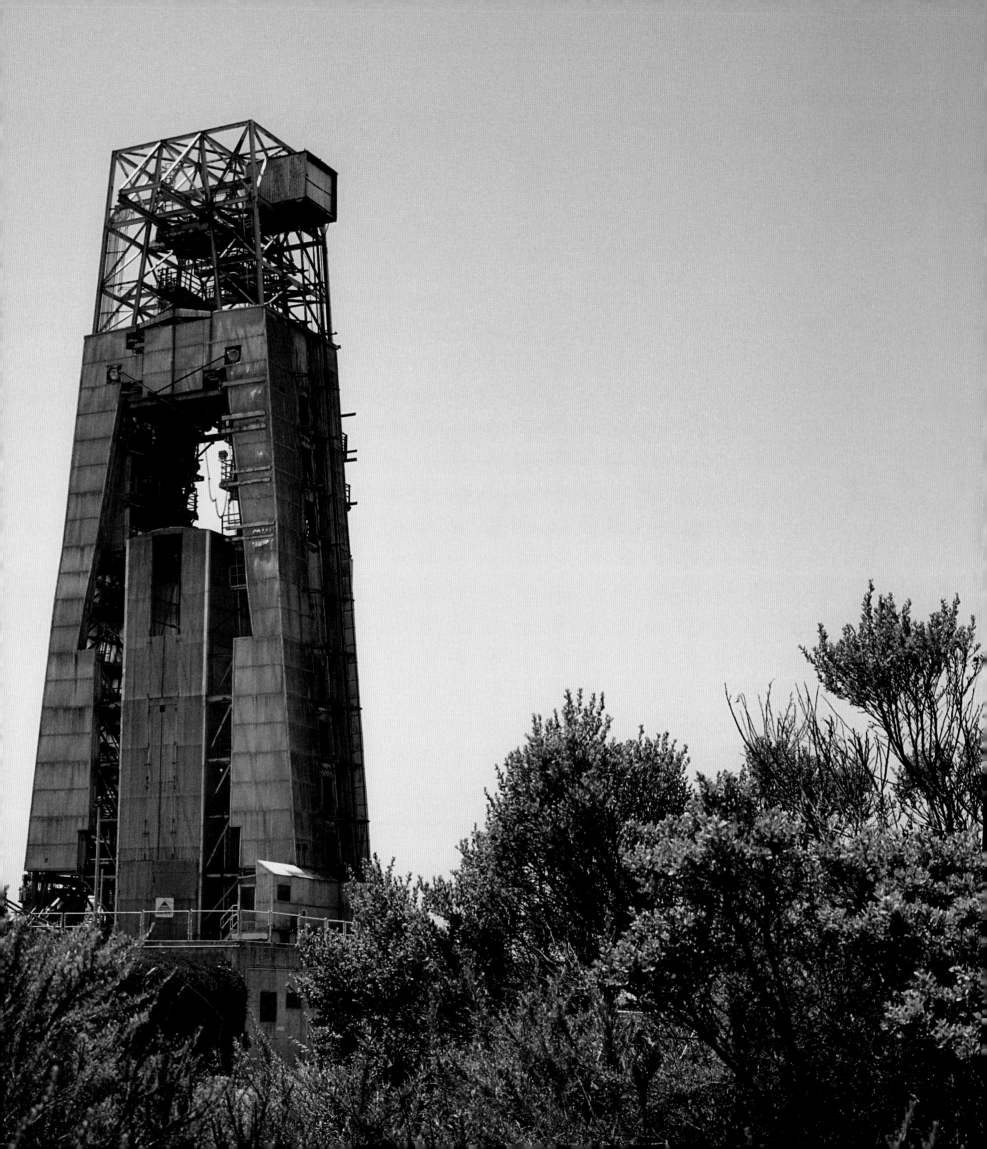

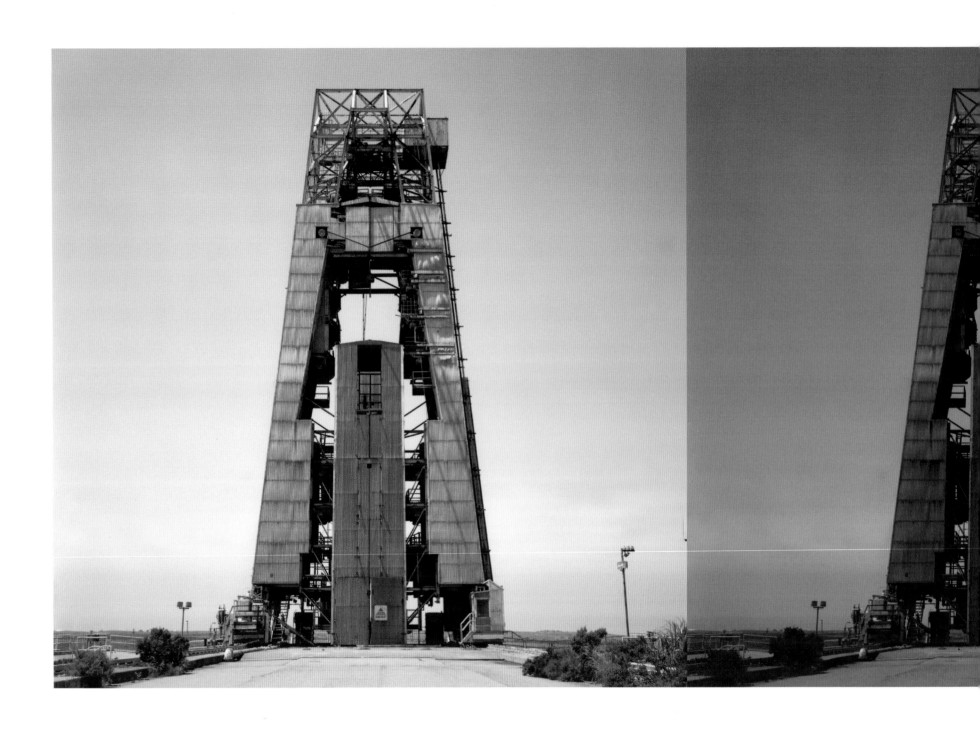

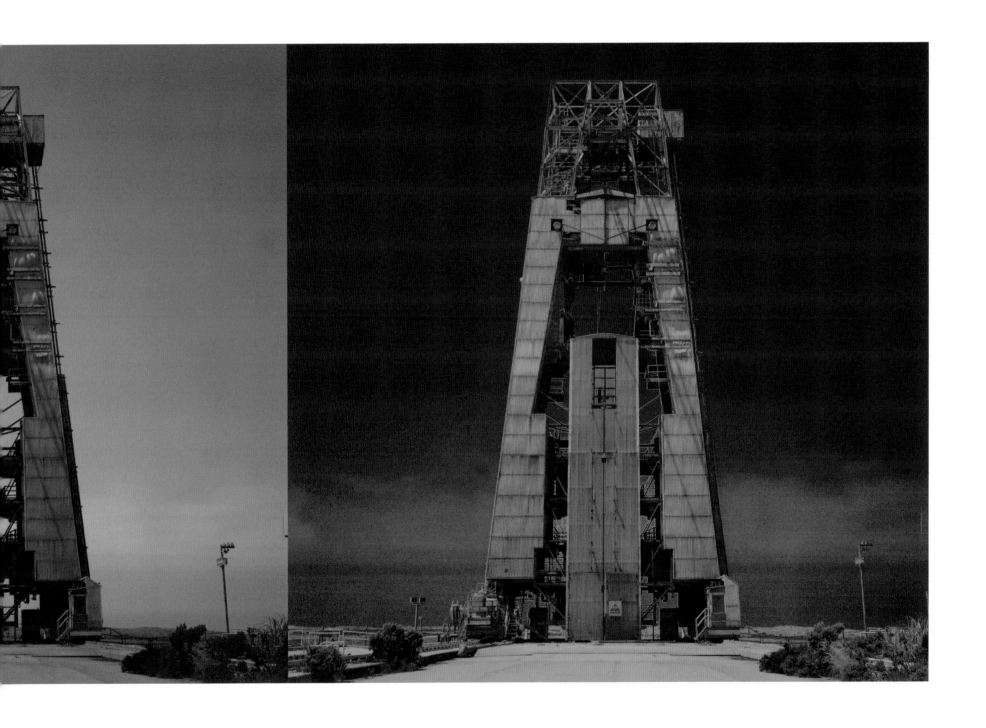

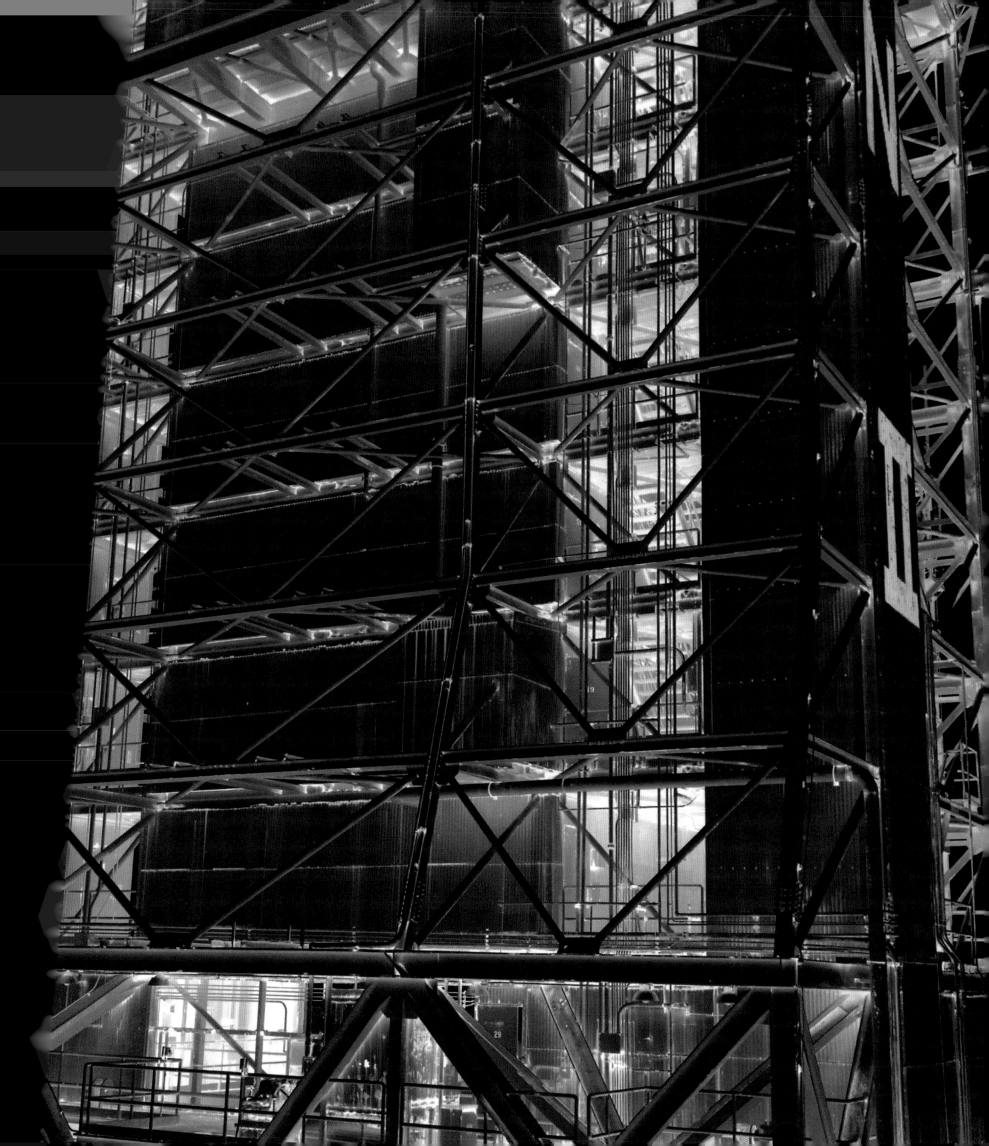

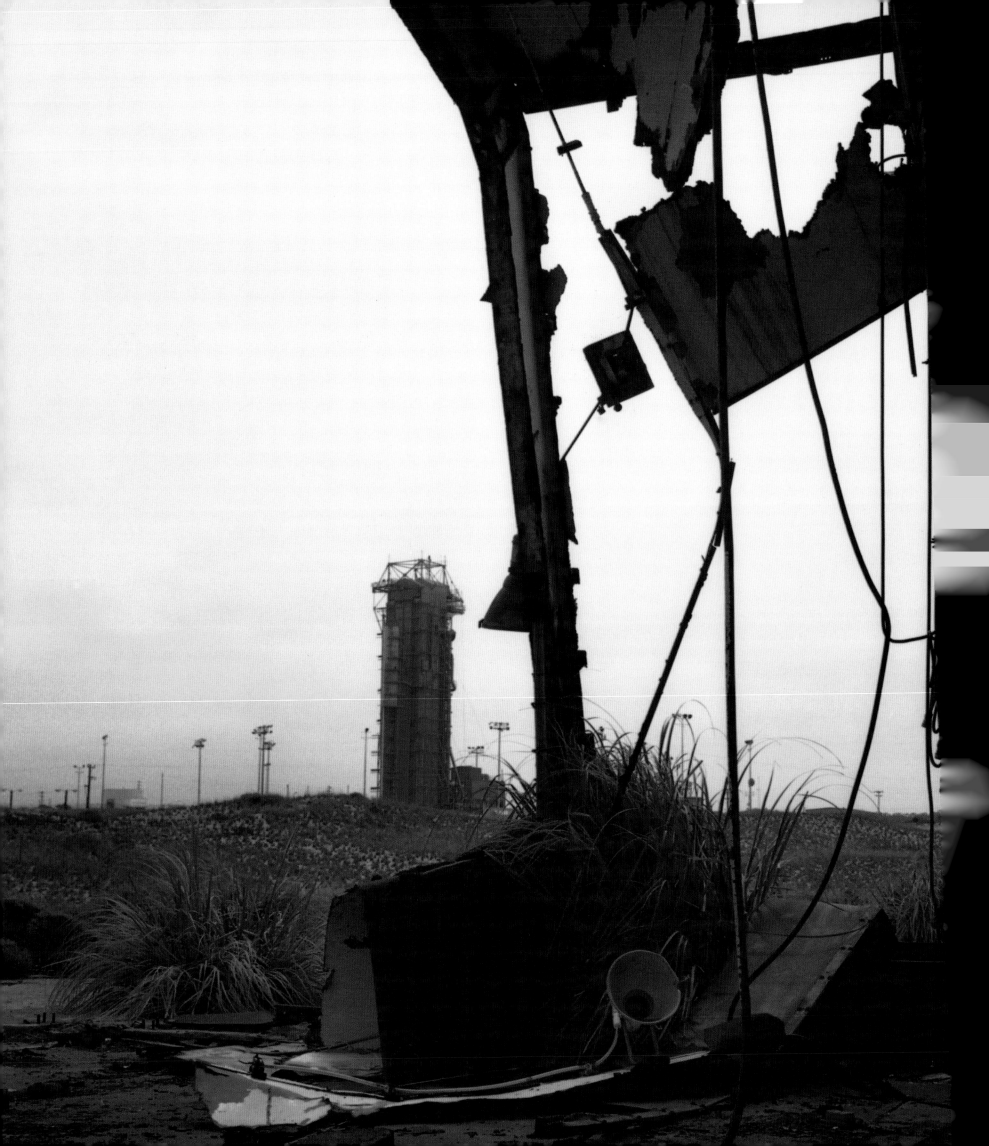

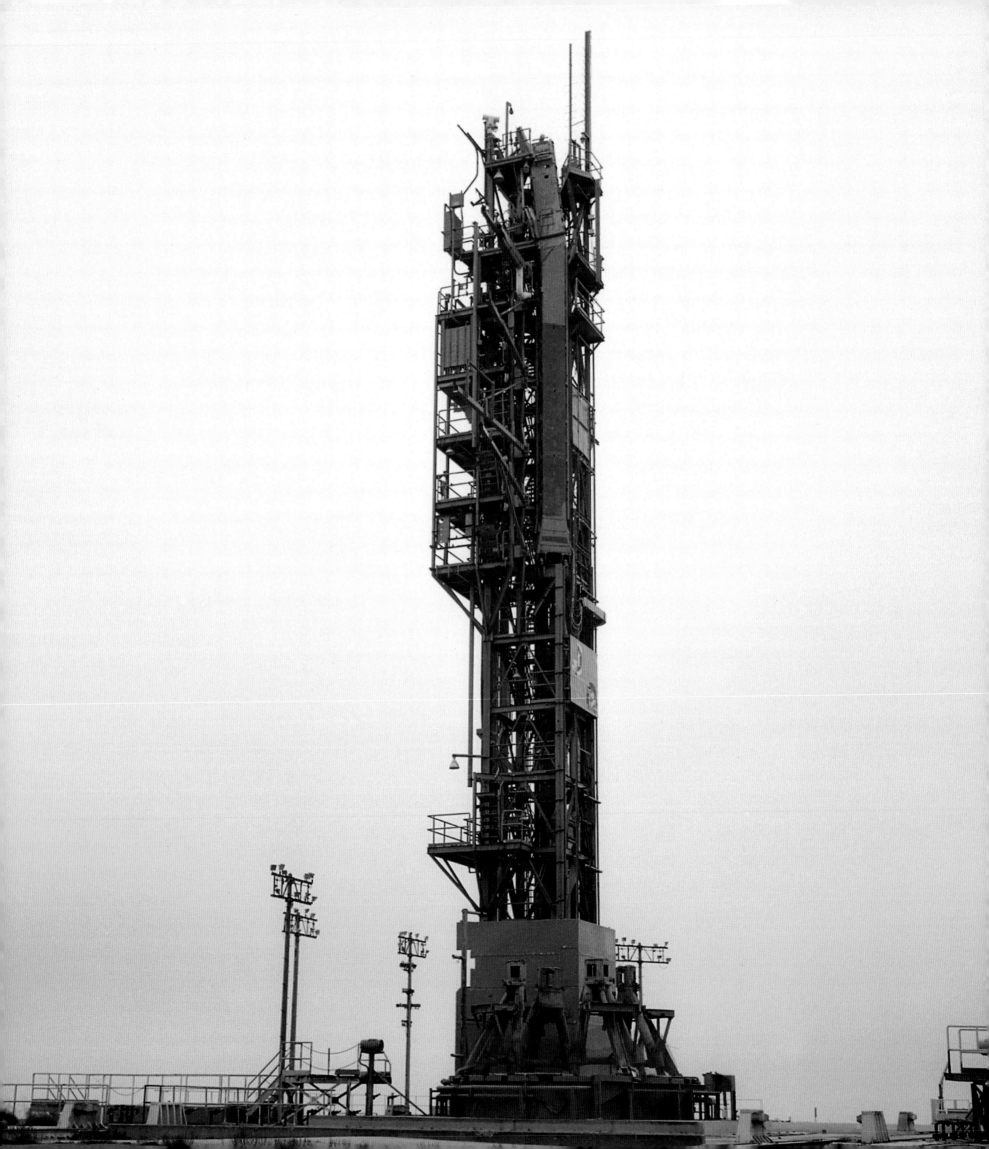

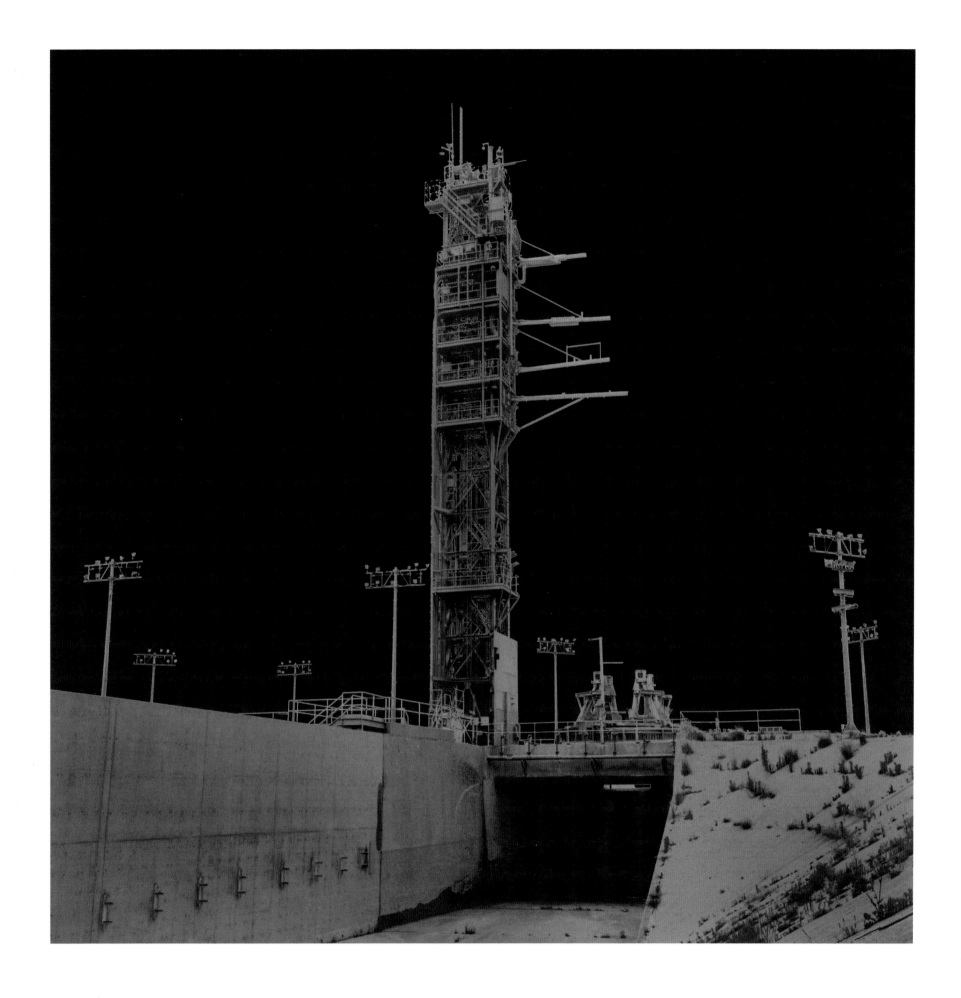

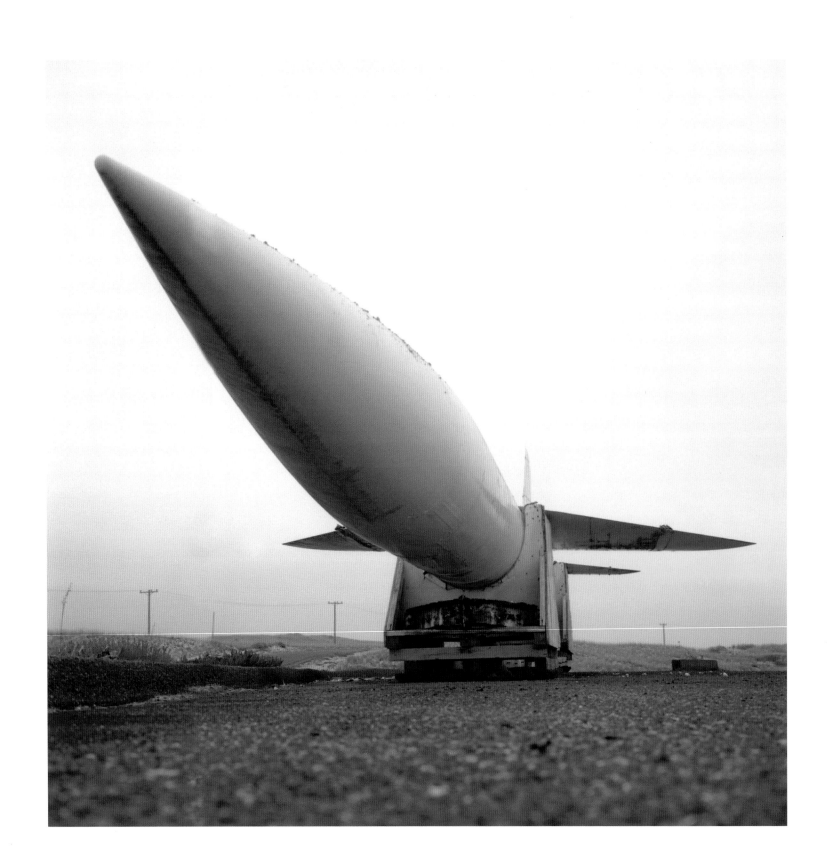

CAPTIONS

GEMINI NORTH OBSERVATORY
MAUNA KEA, HAWAII
35, 36-37, 38, 39, 40-41: FREDERICK
C. GILLETT GEMINI NORTH TELESCOPE

CENTRE SPATIAL GUYANAIS
KOUROU
FRENCH GUIANA
42-43: PARASAIL
44: LAUNCH PAD
45: RADIO TOWER
46: ROCKET SILO
47: ROCKET SILO
48-49: LAUNCH, ARIANE IV

BAIKONUR COSMODROME
BAIKONUR
KAZAKHSTAN
51, 52, 56: SOYUZ TMA-3
53: PROTON LAUNCH VEHICLE
55: LAUNCH VEHICLE ERECTOR
57: OBSERVERS AT LAUNCH OF THE SOYUZ
TMA-3, LOCATION 18
58, 59: FUEL LINE, ABANDONED LAUNCH SITE
60-61, 62, 63: LAUNCH PLATFORM,
ABANDONED LAUNCH SITE
64-65: VIEW FROM LAUNCH PLATFORM
67: TRACKING INSTALLATION
68, 69: ABANDONED LAUNCH SITE
71, 72, 73: BLAST PIT, ABANDONED LAUNCH
SITE
74: INSIDE TRACKING ANTENNA
75: OBSOLETE TELECOMMUNICATIONS,
LOCATION 18
76, 77, 78-79: ERECTION OF SOYUZ TMA-3,
800TH LIFT-OFF, LOCATION 1
80-81, 83: LAUNCH OF THE SOYUZ TMA-3,
LOCATION 18

CAPE CANAVERAL AIR FORCE STATION
FLORIDA
85, 86, 87, 88-89: COMPLEX 34, APOLLO/
SATURN, 1 & 1B DISMANTLED

KENNEDY SPACE CENTER
FLORIDA
90-91, 92, 95: LAUNCH COMPLEX 39, PAD B
SPACE SHUTTLE ACTIVE
93: LAUNCH COMPLEX 39A
96: THOR-ABLE, ROCKET GARDEN
97: MERCURY-ATLAS, ROCKET GARDEN
98, 99: ENGINE, ROCKET GARDEN
100: ABANDONED SATURN V LAUNCH FACILITY

EDWARDS AIR FORCE BASE
CALIFORNIA
103: ABANDONED ANTENNA CONTROLLER
104, 105, 106, 107, 112-113: ROCKET ENGINE
TEST STAND, AFRPL,
108-109: BLAST PIT WATER RECOVERY POOL
110: WIND TUNNEL ENGINE
111: TITAN SRM TEST FACILITY, AFRPL

VANDENBERG AIR FORCE BASE
CALIFORNIA
115, 116, 117: DELTA ROCKET LAUNCH PAD
119, 122: TITAN II LAUNCH PAD, SPACE LAUNCH
COMPLEX-4 WEST
120-121: ABANDONED ROCKET MOTOR STORAGE
123: LAUNCH PAD
124: PROTOTYPE EARLY CRUISE MISSILE DESIGN

ACKNOWLEDGMENTS

Alden Richards
President and Chief Executive Officer
Space Machine Advisors, Inc.
Norwalk, Connecticut

Richard L. Guest
Chief Financial Officer
Space Machine Advisors, Inc.
Norwalk, Connecticut

Ranney Adams
Public Affairs
Edwards Air Force Base, California

Col. Drew Jeter
Commander
95th Air Base Wing
Edwards Air Force Base, California

Sgt. Rebecca Danet
Public Affairs
Vandenberg Air Force Base, California

Col. Frank Gallegos
Commander
30th Space Wing
Vandenberg Air Force Base, California

Kenneth E. Warren
Chief of Operations
45th Space Wing Public Affairs Office
Patrick Air Force Base, Florida

Kandy Warren
Public Relations Office
Kennedy Space Center, Florida

John H. Johnson
Director
Apollo One Memorial Foundation, Inc.,
Cape Canaveral, Florida

Manny R. Virata
Lead Media Projects
Media Service Division
Kennedy Space Center, Florida

Carver Glenn Mahone
Assistant Administrator for Public Affairs
NASA, Washington, D.C.

George Butler
White Mountain Films,
New York, New York

Gert Weyers
Mir Corp, Moscow, Russia

Jeffrey Manber
Mir Corp, Moscow, Russia

S.P. Korolev Rocket
and Space Corporation Energia
(provided support for visit to Baikonur)
Korolev, Russia

Russian Federal Space Agency formerly
Russian Aviation and Space Agency
(provided permission to visit Baikonur)
Moscow, Russia

Dmitry Speransky
S.P. Korolev Rocket and
Space Corporation Energia
Baikonur, Kazakhstan

Sergey V. Soloviev
Deputy Head of Versatile Complex
"Stand-Start"
Baikonur Cosmodrome, Kazakhstan

Claudia Hoyau
Head of External Relations Office
Arianespace, Kourou, French Guiana

Mario de Lepine
Media Relations
Arianespace, Evry-Courcouronnes,
France

Jacqueline Schenkel
Spokeswoman
Arianespace, Washington, D.C.

Marie-Françoise Bahloul
Press Officer
Centre National D'Etudes Spatiales
Kourou, French Guiana

Joseph R. Wright, Jr.
President and Chief Executive Officer
PamAmSat Corporation
(Request for transport to a launch)
Wilton, Connecticut

Peter D. Nesgos
Partner (heads Space Law Practice)
Milbank, Tweed, Hadley & McCloy, LLP
New York, New York

———

Thank you to:
Gianfranco Monacelli, Andrea Monfried,
Elizabeth White, Stacee Gravelle
Lawrence, and Joesph Villella at
The Monacelli Press; Ethan Trask at
Helicopter, L.L.C.; Edwynn Houk and Julie
Castellano at the Edwynn Houk Gallery;
Melissa Harris at Aperture;
Philippe Laumont and Albert Fung at
Laumont Editions; Steve Rifkin, Joe
Hartwell, Mark Sage, Andy Baugnet, and
Peter Sullivan at Hank's Photographic
Services; Dmitry Speransky; John Thomas
at Stout, Thomas & Johnson Esq.;
Rebeccah Johnson, Studio Manager; Chad
Kleitsch, Digital Imaging/ Color Printing;
and Heather Sutfin, studio assistance at
the Lynn Davis Studio

And a special thank you to:
Alan Weisman; Alden Richards;
Gert Weyers and Misha Porollo;
and my husband Rudy Wurlitzer